BOTERO ABU GHRAIB

With an essay by David Ebony

PRESTEL

MUNICH · BERLIN · LONDON · NEW YORK

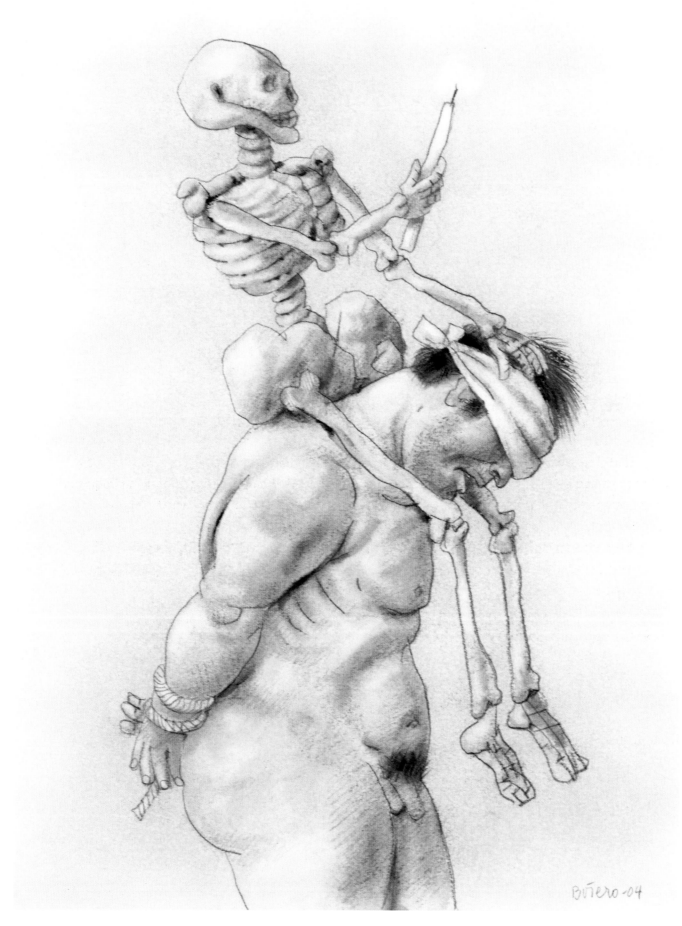

Fernando Botero, Untitled, 2004, pencil/paper, 41 x 31 cm

BOTERO ABU GHRAIB

David Ebony

I.

On the evening of April 28, 2004, the CBS-TV news program *60 Minutes* broadcast a report describing abuse of Iraqi prisoners by United States soldiers at the Abu Ghraib prison near Baghdad. The story, aired after several Pentagon requests for delays had been granted, in order to avoid increased violence against U.S. troops in Iraq, featured a number of now-infamous photos, taken by soldiers, of prisoners being subjected to physical and psychological abuse. Earlier that day, Secretary of Defense Donald H. Rumsfeld had briefed Congress on the impending scandal. Two days later, the first article about the events to appear in print, "Torture at Abu Ghraib," by veteran journalist Seymour M. Hersh, appeared in the *New Yorker*, accompanied by a number of photos taken in the prison. News media around the world soon picked up the story. Perhaps most notable among pieces appearing in subsequent weeks was Susan Sontag's persuasive essay "Regarding the Torture of Others," in the *New York Times Magazine* of May 23, which was accompanied by several graphic images.

The administration of George W. Bush seemed to respond to the Abu Ghraib story as a public relations problem. From the outset of the Iraq invasion, the administration had carefully controlled images released to the public. Despite what many saw as a violation of international law and disregard of the U.N. Charter, the invasion had proceeded as planned. The Iraqi military was defeated and Baghdad fell on April 9, 2003. Baath Party rule ended and Saddam Hussein was removed from office by May 1. The "shock and awe" Baghdad blitz that began the war had played out in garish detail on television like a Hollywood "B" movie, but the administration banned images of dying Iraqis and of returning coffins of U.S. soldiers who had perished in Iraq. The administration managed to convince many Americans that the Iraq invasion was a logical and justified move to counter terrorism in response to the September 11, 2001, attacks on the World Trade Center in New York and the Pentagon in Washington, D.C.

Prior to the invasion, the immense (280-acre) Abu Ghraib prison, about 20 miles west of Baghdad, was one of the principle holding places for enemies of Saddam Hussein's regime. As many as 50,000 men and women were crammed into the facility at times. Inmates occupied tiny twelve-by-twelve foot cells. The U.S. State Department reminded the public that Saddam had killed 4,000 prisoners at Abu Ghraib in 1984. Such statistics were valuable to the Bush administration when the pretext for the invasion, Saddam's possession of weapons of mass destruction, proved to be unfounded. The administration then adopted the rationale that Saddam had to be deposed because of his human rights abuses.

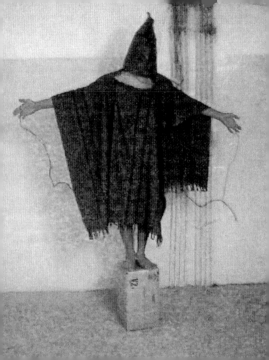

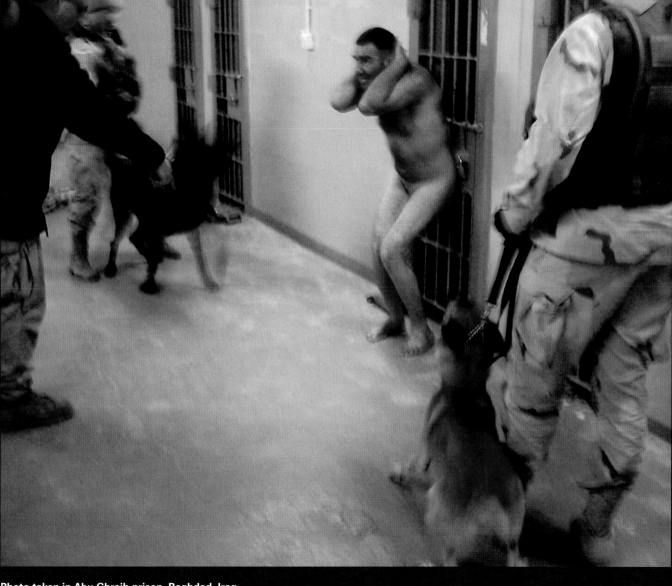

Photo taken in Abu Ghraib prison, Baghdad, Iraq

After Saddam fell, Abu Ghraib had been sacked by local residents and the prisoners dispersed. As the insurgency against the U.S. occupation gained strength, the Pentagon decided to restore the facility for use as a detention center for suspected insurgents. Some 5,000 Iraqis were eventually held in the prison now under U.S. command, detained for possible terrorist activities or alleged crimes against Coalition forces comprising American troops and a smaller international military presence.

Placed in charge of Abu Ghraib was Brigadier General Janis Karpinski, a business consultant in civilian life who had no experience in running a prison. Under her command were 3,400 army reservists. From October through December 2003, sadistic and blatant criminal abuse of prisoners was carried out in Tier 1A at Abu Ghraib by military police from the 372nd MP Company. In January 2004 Karpinski was quietly removed from the post as an extensive investigation of the U.S. military's prison system in Iraq began.

Revelation of the Abu Ghraib scandal stemmed from an investigative report by General Antonio M. Taguba. The classified report was leaked to the media, as was incriminating visual evidence of torture and humiliation of prisoners. American soldiers stationed at Abu Ghraib took hundreds of digital photos and videos (which have not been made public to date) inside the prison, exchanging

them with other soldiers via laptop computers and emails. As a result of the Abu Ghraib debacle, most U.S. soldiers in Iraq are now prohibited from taking photographs and videos while on duty.

According to reports and soldiers' testimony, detainees were selected for "softening" prior to being interrogated about the activities and whereabouts of insurgents. The inmates were routinely stripped naked and subjected to various forms of humiliation and abuse as part of this "softening." Guards regarded the detainees as terrorists rather than as prisoners of war, and thus their rights were ignored and they were subjected to treatment that violated the Geneva Convention. In the wake of the investigation and resulting scandal, some of the soldiers were arrested and brought to trial. All of the accused guards claimed that superior officers instructed them to apply extreme methods, but convictions and sentences were handed down only to low-level servicemen and -women. While some Pentagon apologists tried to dismiss the scandalous activities as sophomoric pranks, the investigation reports, as well as the overwhelming visual evidence, confirms far more sinister proceedings.[1]

According to the reports, chemical lights were broken and the contents were poured on some prisoners. Others were beaten with broomsticks and chairs. While some detainees were thrown naked into wet and freezing cells

to languish for days without food or water, others were made to stand on boxes for hours, with wires attached to their genitals. The prisoners were told that the wires were electrified and that they would be electrocuted if they stepped down from the boxes.

Exploiting Islam's ban on homosexual acts, and the perception that for Iraqi men it is humiliating to be naked in front of other men, the soldiers threatened the nude male detainees with rape and forced them to simulate sex acts with each other. Some of the men were humiliated by being forced to wear women's underwear. Otherwise naked, they appear in the photos chained to bunk beds; one shows a male prisoner in women's underwear hanging upside down from an upper berth. Some prisoners were made to climb naked atop groups of nude men to form a kind of human pyramid. Sworn testimonies of a number of inmates mention being routinely pissed on my male soldiers, and having their anuses probed with broomsticks by both male and female soldiers. Military dogs were frequently used to taunt the inmates, and in a number of instances the dogs were allowed to attack and bite them. Soldiers with no medical training stitched up prisoners' wounds using no anesthetic or antiseptic. A number of prisoners died while in custody. Many of these sorts of abuses are evident in the dozens of photos that were made public. Numerous other Abu Ghraib photos and videos, allegedly even more horrific, have been withheld by Congress and the Pentagon because of their potentially inflammatory content.

II.

The horrors of Abu Ghraib would seem to be an unlikely choice of subject for Fernando Botero. Yet the Colombian-born artist, best known for more lighthearted compositions, created in 2004 and 2005 a stunning series of some fifty major canvases and numerous drawings that focus on the hellish prison. These works, which caused a stir when they were first shown as part of museum surveys of Botero's work in Italy and Germany in 2005 and early 2006, now occupy a key position in his long and distinguished career. [2]

One of Latin America's most successful and beloved artists, Botero is internationally renowned for colorful, folksy paintings, drawings, and sculpture produced over the course of five decades. Art audiences, critics, and collectors see the famously rotund figures that populate his compositions as emblematic archetypes: sensuous icons of plenty, of good health and good fortune. He has accomplished a unique merging of naïve art, the Colonial Baroque art of his homeland, and sophisticated European art, particularly that of the Italian Renaissance. Over the years he has developed a rarefied visual vocabulary that is universally understood and admired. Professionally, Botero has always regarded himself as a loner, outside

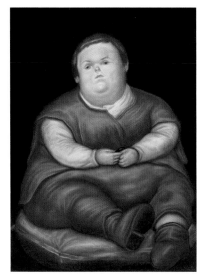

1 Fernando Botero
El Niño de Vallecas (after Velázquez), 1973, 174 x 126 cm

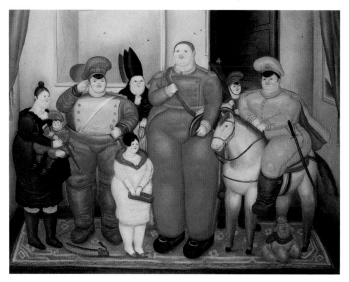

2 Fernando Botero
Official Portrait of the Military Junta,1971, 171 x 218 cm

the mainstream of contemporary art. However, while he has always maintained a preference for the conventional mediums of painting and sculpture, Botero's often jarring exaggerations of volumes in space, proportion, and scale seem very much in step with the recent avant-garde, as they parallel those of a younger generation of much sought-after figurative painters such as John Currin, Lisa Yuskavage, and Dana Schutz.

Early on, countering claims that his figures appear to be fat, Botero replied, "They look rather slim to me. My subject matter is sometimes satirical, but these 'puffed-up' personalities are being puffed to give them sensuality ...In art, as long as you have ideas and think, you are bound to deform nature. Art is deformation. There are no works of art that are truly 'realistic.'"[3]

His figures are exaggerated principally in terms of their volumetric relationships to their surroundings, whether landscapes, interiors, or street scenes. From the artist's careful observation of nature (Botero often sketches from live models), the figures evolve into forms that at least one critic has referred to affectionately as "Boteromorphs."[4] While not exactly mesomorphs, Boteromorphs possess hearty, heroic body types. They often suggest an ability to overcome intensely adverse circumstances. This is especially evident in the Abu Ghraib pictures. The majority of the prison inmates certainly did not possess the beefy bodies

that Botero depicts. The bulky forms, however, suggest a psychological and moral weightiness that commands, if it does not overwhelm, their confined spaces.

Botero's best-known pieces, full of wit and charm, feature monumental male and female figures, cherubic children, lively musicians, pampered pets, and sumptuous still-lifes. The subjects often seem schematic and simple, but they are deceptively so. Thematically, Botero has covered a broad range over the course of his career, addressing sunny topics such as nature's abundance and domestic bliss as well as more problematic issues including social inequity, sexual identity and mores, political intrigue, and global conflict. In each work, he manages to convey a feeling of innocence tempered by knowing and often acerbic social comment.

Again and again in his art, Botero champions the abject, the downtrodden, the underdog, and the Everyman. Among the earliest of his endeavors to attract some controversy was a series of paintings and drawings begun in 1959 that were inspired by Diego Velázquez's sympathetic portraits of the dwarves who served and entertained the court of Phillip IV in the seventeenth century. In *El Niño de Vallecas (after Velázquez)*, 1959, for instance, Botero emphasizes the forlorn expression on the boy's face, exaggerating the proportions of the head that nearly fills the upper portion of the large

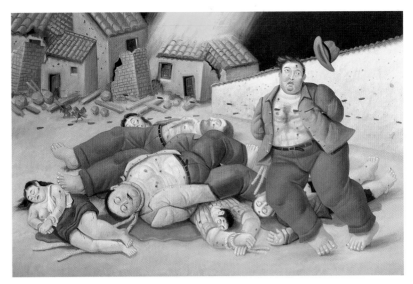

3 Fernando Botero
Massacre in Colombia, 1999, 129 x 192 cm

4 Fernando Botero
Massacre in the Cathedral, 2002,
196 x 131 cm

canvas. Using frenzied brushwork in a style reminiscent of de Kooning's Woman series, Botero departs from Spanish realism, yet manages to amplify the feeling of compassion for the subject so evident in the Velázquez work. Botero created a number of variations of this image in subsequent years (fig. 1).

Many of his works are inspired by day-to-day activities of townsfolk in the small Colombian villages where he was raised. In Botero's vision, ordinary men and women are transformed into heroic protagonists. Even in the midst of mundane chores, they maintain a posture of solemn dignity. For instance, Botero depicts prostitutes as modern-day Venuses, each exuding a sense of dignity and pride as she peers into a mirror. Children and the elderly are given pride of place in every composition in which they appear.

In contrast to this treatment, figures of authority are routinely satirized. Beginning in the early 1970s, paintings such as *Official Portrait of the Military Junta*, 1971 (fig. 2), poke fun at the trumped-up grandeur of the military leadership then in control of Colombia and other Latin American states. Bloated by an air of self-importance, these figures in full-dress uniform stand at attention stiffly, towering over their diminutive wives, children, and followers. Flies buzzing around the heads of the officers add to the overall tone of decadence, suggesting a regime that is polished on the outside but rotting at its core.

A more specific precursor of the Abu Ghraib series is a large 1973 painting, *War*, that powerfully conveys the senselessness of armed conflict. Against a stark gray background is a huge mound of bodies, men, women and children, bleeding and dead, some naked, some partially clothed. Some grasp at money or a flag. Botero painted the work in response to news reports of the Yom Kippur War between Israel and its Arab neighbors, but the image also alludes to "La Violencia," a period of political turmoil in Colombia in the late 1940s — formative years for Botero — which left more than 300,000 persons dead or missing.

More recently, in the late 1990s, Botero embarked on a series of paintings that address the brutal violence of the so-called drug cartel wars that have plagued Colombia for nearly forty years. In 2004 he donated more than fifty paintings and works on paper from the series to the National Museum of Colombia in Bogotá and the Antioquía Museum in Medellín. In this series he turns his attention to the victims of death squads, massacres, car bombs, and kidnappings. Works such as *Massacre in Colombia* (fig. 3) and *Massacre on the Best Corner* (both 1999) show innocent men, women, and children being indiscriminately shot by drug lord thugs in or near his hometown of Medellín. *Massacre in the Cathedral* (fig. 4), a large canvas showing mutilated bodies lying beneath the rubble of a ruined church, was created in quick response to news reports of a 2002 rocket attack

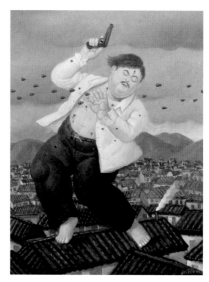

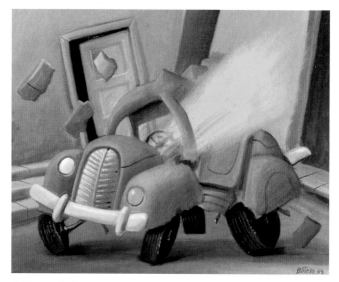

5 Fernando Botero
Death of Pablo Escobar, 1999, 46 x 34 cm

6 Fernando Botero
Carbomb, 1999

launched by drug lord renegades on rural churchgoers, killing 120 persons, including 40 children. Botero was motivated to create these works in reaction to news items about the incidents, just as his response to news of the Abu Ghraib scandal resulted in the more recent series.

Botero met with considerable criticism in the press for his depiction of drug lords Manuel Marulanda and Pablo Escobar. Some critics claimed that the works immortalize the feared outlaws to the shame of all Colombians. Based on news reports of Escobar's death when government agents gunned him down, *Death of Pablo Escobar* (1999) (fig. 5), for example, shows the barefoot criminal in a hail of bullets, teetering on a tiled rooftop of a Colombian village.

Botero defended these works in the press, stating, "They are not a political commentary. Marulanda and Escobar are part of our dark history. I had to paint them because they are, sadly, people of great importance in Colombia ...part of our dark folklore, just as Al Capone is part of the dark folklore of the United States."[5] Similarly, Botero treats the Abu Ghraib story as a historical fact that is an unfortunate part of the legacy of the Iraq war, but also encompasses a lesson of morality and justice that could have far-reaching implications.

Even without the use of figures Botero manages to convey a powerful statement against violence in

Carbomb (1999) (fig. 6), a particularly poignant image of an act of terrorism. For Botero such works have a deeply personal resonance. As one of Colombia's wealthiest and most prominent celebrities, he has been the target of kidnappers. Though their efforts have been thwarted, he has been forced in recent years to keep visits to his hometown brief and well guarded. In 1995 unidentified persons set off a bomb in a flowerbed between the legs of one of the giant bronze "doves" he had donated to a public park in Medellín. Twenty-seven people died in the incident and some two hundred were wounded.

III.

Though the "drug cartel" works refer to a specific socio-political dilemma, each piece conveys a universal protest against violence. Likewise, the Abu Grahib works represent for Botero "both a broad statement about cruelty and at the same time an accusation of U.S. policies."[6] Ultimately, the series suggests an impassioned call for humanity in the face of man's inhumanity to man. "It is important that the American public sees these works because those who did the atrocities were Americans," the artist has said. "To the credit of the Americans, it was from the American press that I learned of that situation, and I am sure that the vast majority of Americans oppose what happened in Abu Ghraib."

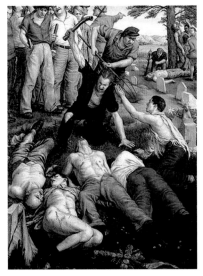

7 Paul Cadmus
The Herren Massacre, 1941,
The Columbus Museum of Art, Ohio

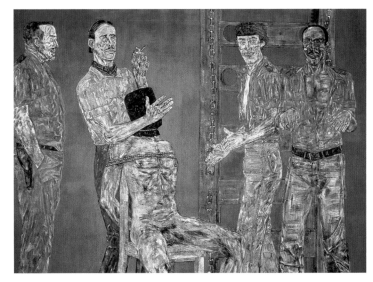

8 Leon Golub
Interrogation II, 1981, 120 x 168 in.

Botero is familiar with the vicissitudes of this nation's political climate and the diversity of its people, having worked and studied in the U.S. for 13 years, from 1960 through 1973, encompassing the period of Vietnam war protests and social upheaval. His disillusionment with the political situation in the U.S., as well as a feeling of isolation in the New York art world, precipitated his decision to make Paris his home base.

Botero, like many people around the world, reacted with shock, horror, and anger as news of Abu Ghraib broke. An admitted news addict, he watched CNN and other television news outlets in his Paris home, read the *New Yorker* article and other journals and newspapers, and surfed the Internet for further details of the story. "I, like everyone else, was shocked by the barbarity, especially because the United States is supposed to be this model of compassion," he later told the Associated Press.[7] The artist felt compelled to speak out about the incident. Setting to work with his usual feverish creative energy, Botero, at 73, produced within a year some fifty major Abu Ghraib paintings and dozens of related drawings.

His artistic statement seems particularly bold in light of the fact that most other artists were slow to respond to Abu Ghraib or to comment on the war in Iraq in general. In New York there were surprisingly few gallery exhibitions protesting the war in the months immediately following

the invasion. Artists produced few images in direct response to the Abu Ghraib atrocities. There was even less of a response among art world institutions. In September 2004, New York's International Center of Photography mounted an important exhibition of the Abu Ghraib photos, however, which ran concurrently with a showing at the Andy Warhol Museum in Pittsburgh.[8]

The scant number of American artists willing to respond to Abu Ghraib is surprising considering the country's long tradition of tackling front-page headlines with violent content and politically loaded themes. For example, Paul Cadmus, an artist who was no stranger to controversy, produced in 1941, on the eve of World War II, *The Herren Massacre* (fig. 7), a painting centered on a labor dispute with striking miners that took place some years earlier. The miners massacred twenty-six strikebreakers and were never brought to trial. Cadmus's exaggerated style in some ways parallels Botero's, as does the sensuality of his male figures in this provocative composition, originally commissioned by *Life* magazine for an article about artists' responses to significant news events. The image was finally rejected for reproduction for a number of reasons, among them that Cadmus had shifted the scene of the crime to a military graveyard.

Other examples of the period could include Philip Guston's caustic images of hooded Ku Klux Klan figures of the

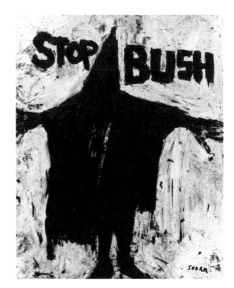

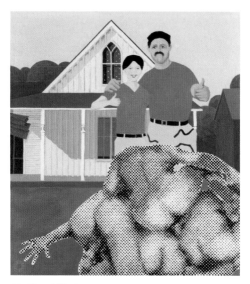

9 Richard Serra
Stop Bush, 2004

10 Gerald Laing
American Gothic, 2004

late 1930s and early '40s. Later, in the 1970s, with his social conscience reawakened by Nixon's outrages, he produced his "Poor Richard" series of satirical paintings and drawings. Also notable are Leon Golub's monumental canvases of the 1980s, which in some ways anticipate Botero's Abu Ghraib series. Golub's harsh and violent images depict activities of mercenary soldiers in covert operations in Central America and elsewhere. A painting such as his *Interrogation II* (1981) (fig. 8), showing a group of mercenary thugs intimidating a naked and defenseless captive, corresponds on a number of levels with Botero's view of Abu Ghraib.

A few other artists did come forward with responses to Abu Ghraib. Soon after the incident came to light, Richard Serra produced a powerful image, *Stop Bush*, which employs a silhouette of the well-known figure of a detainee standing on a box, clothed in a sack and with a sandbag covering his head, his limbs attached to wires (fig. 9). The words "Stop Bush" are scrawled with a graffiti-like sense of urgency alongside the figure. The work was eventually reproduced in numerous publications and it was included in the 2006 Whitney Biennial. Other artists from the U.S. and abroad, such as Thomas Hirshhorn, Paul McCarthy, Hans Haacke, Jenny Holzer, and Susan Crile have touched upon the scandal in recent works. And the veteran English Pop artist Gerald Laing mounted a show in 2004 at New York's Spike Gallery, which featured

acerbic paintings incorporating Abu Ghraib images. One potent example, *American Gothic* (2004), based on the iconic Grant Wood painting, replaces the wholesome farmer couple with the notorious pair of male and female guards who are wearing blue latex gloves and giving the "thumbs up" sign to a pyramid of naked Iraqi prisoners (fig. 10).

IV.

Botero's approach to the Abu Ghraib story is more direct and confrontational than most of the others who tackled the theme. His figures are schematic, yet convincing, and his references to art-historical precedents in the work lend the series a profound sense of conviction and authority. Although Botero's renderings of these muscular bodies are consistently elegant and sensuous, the compositions never fail to evoke the horrific circumstances of the scene. One could compare his studies of single figures, such as the drawings of male captives, *Abu Ghraib 20, 22, 31, 37* and *41* (plates pp. 46, 22, 57, 65, 64) and of the female figure in *Abu Ghraib 28* (plate p. 47) with drawings by Michelangelo. The crisp, assured line and the subtle nuances of volume and shade Botero employs reflect, perhaps better than any of his previous works, his thorough knowledge of human anatomy and his profound understanding of and appreciation for Renaissance art. Many of the figures in the series convey a greater feeling

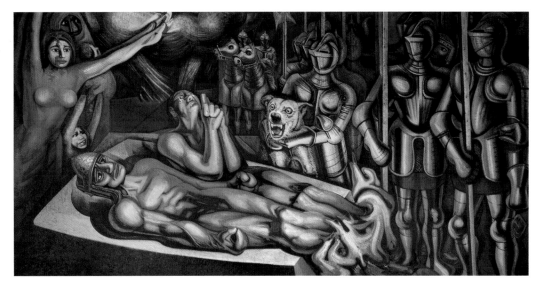

11 David Alfaro Siqueiros, *Monument to Cuauhtémoc: the Torment*, 1956, mural,
Palacio de Bellas Artes, Mexico City

of naturalism and a livelier sense of movement than anything that has appeared in Botero's art thus far.

Botero based his Abu Ghraib compositions on written testimony as much as on the photographic material. The first work he produced in the series, *Abu Ghraib I* (2004) (plate p. 92) is a drawing showing on the left two highly stylized but ferocious-looking guard dogs on leashes as they lunge at two naked and blindfolded male prisoners on the right. The man in the foreground lies prostrate while the other kneels in fearful supplication in the background.

The prison dogs and the terror they instilled in the captive Iraqis are of particular interest to Botero. Unlike the overfed and complacent pets that appear in a number of his earlier works, these are ferocious beasts baring their teeth. *Abu Ghraib 6* (plate p. 95) shows the head of a dog snarling inches away from the face of a blindfolded man appearing to scream in terror.

The large oil paintings *Abu Ghraib 45* (2005) (plate p. 89) and *Abu Ghraib 56* (2005) (plate p. 25) even more explicitly evoke the terrible role of the guard dogs. The former shows a huge dog standing atop a bound and blindfolded, partially naked man lying face down on the floor. The dog's sharpened claws bloody the prisoner's back. More directly based on a photo than most other works in the series,

Abu Ghraib 56 depicts a nude prisoner cowering in fear as he is confronted on several sides by the fierce canines.

An erudite and conscientious student of art history, Botero always embellishes his works with art-historical references and the Abu Ghraib series is no exception. Allusions to Christian iconography from Medieval and early Renaissance art are apparent, despite the irony of using Christian motifs in the depiction of Islamic men and women. Especially evident are his references to the passion of Christ. Compare, for instance, the bleeding blindfolded man in *Abu Ghraib 66* (plate p. 101) with the anguished Christ in "Man of Sorrow" paintings by Hans Memling (after 1490), in the Christian Museum, Esztergom, and by Aelbrecht Bouts (1452-1549), in the Musée des Beaux-Arts, Lyon. Also referenced are the sacred images of martyred saints in Baroque art. The strained limbs of the tethered prisoners in *Abu Ghraib 20, 31, 41* and *43* (plates pp. 46, 57, 64, and 69) echo, for example, those of the central figure in *The Martyrdom of St. Philip* (1639) by Jusepe de Ribera, in the Prado.

The first work that comes to mind when viewing Botero's paintings and drawings with dogs is the mural by David Alfaro Siqueiros in the Palacio de Bellas Artes in Mexico City, *Monument to Cuauhtémoc: the Torment* (fig. 11). Siqueiros's impassioned composition, which Botero certainly studied when he lived and worked in the Mexican

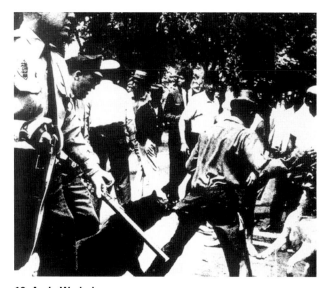

12 Andy Warhol
Race Riot, 1964

capital in 1956, shows the last Aztec emperor as he is about to be vanquished by Hernan Cortés and the conquistadors. Lying naked and prostrate on a stone slab, the ruler pleads for mercy from the Spaniards as one of their ferocious, drooling dogs snarls close by.

For U.S. audiences, Botero's pictures of ferocious military canines will have perhaps more resonance as they recall Andy Warhol's *Race Riot* series of silkscreen paintings produced in 1964 (fig. 12). The Pop artist's appropriation of a news photograph shows policemen attempting to disperse a civil rights demonstration by blacks in Birmingham, Alabama, with the help of trained German Shepherds. As part of an acerbic commentary on the social ills of his day, Warhol focuses on the image of an animal lunging at a defenseless man as he tries in vain to escape. A prison guard brutally attacking a lone and defenseless inmate is featured in a number of Botero works including *Abu Ghraib* drawings *2, 3, 4, 9* and *16* (plates pp. 82, 72, 34, 73, 35), and in paintings such as *Abu Ghraib 60* (plate p. 58) and the triptych *Abu Ghraib 43* (plate p. 69). Several of these images, and others throughout the series, use the motif of the prison bars in either the foreground or background to confine the figures in space and also to convey the claustrophobia of the jail cells. This motif, too, has a number of art-historical presidents. Consider, for instance, Raphael's fresco *The Deliverance of St. Peter from Prison* (1511-14), which features a view

of the saint behind a grid of prison bars as an angel appears to release him. In other Abu Ghraib works in this group, the guard pulls the prisoner by the hair in a violent gesture The image echoes scenes of victorious warriors taking vanquished captives for sacrifice, a recurring motif in pre-Columbian art.

Perhaps the most disturbing images in Botero's series depict instances of sexual humiliation and sexual abuse as a means to emasculate and intimidate the male prisoners. Forced homosexual behavior at Abu Ghraib was intended to shame prisoners in light of Islam's taboos, and further humiliation was intended when making some men wear women's undergarments. In *Abu Ghraib 47*, a prisoner wearing a pink bra and women's underpants stands upright, his bleeding hands and feet bound by ropes to the jail cell bars on either side of him. A far cry from Botero's well-known paintings of melancholy transvestites, this forlorn figure conjures a crucified martyr, or perhaps more specifically, an Ecce Homo.

Abu Ghraib 59 (plate p. 3) shows a naked man sitting on another man tuned to his side, wearing only a pink bra. On the right, a guard's foot stomps on the prisoner's already bleeding head, while a stream of piss, coming from an unseen guard on the left, showers the hapless pair. In *Abu Ghraib 56* (plate p. 51), a guard's hand sheathed in a blue latex glove pushes a naked captive with a red sack on his lowered head toward a standing prisoner wearing pink

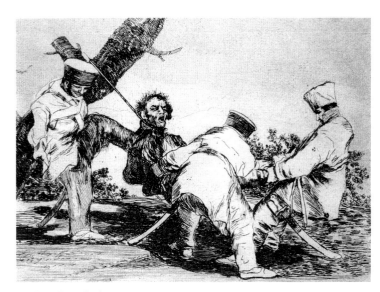

13 Francisco de Goya
Por que? (Why), etching, from *Desastres de la guerra*
(The Disasters of War) 1810-20

underwear, his blindfolded head facing upward. Even as their toes touch, the men, overcome with shame, resist the sexual encounter imposed upon them. Similarly, in *Abu Ghraib 51* (plate p. 24), a guard has forced a prisoner to kneel between the legs of a standing naked man who is bound to the jail cell bars. The kneeling man, defiantly thwarting the implied sex act, screams in anguish as the guard pulls him by his hair.

The sado-masochistic environment established at the prison is suggested by images such as *Abu Ghraib 17, 52* (plates pp. 79, 91). The first drawing shows a naked prisoner writhing on the ground as a guard behind him seems to be probing his anus with his hand. *Abu Ghraib 35* features a trio of naked men, one of whom has a broken broomstick protruding from his anus. In the painting *Abu Ghraib 52* (plate p. 91), a naked man straddles a kneeling man who also has a stick jammed into his injured rectum. *Abu Ghraib 11* and *57* (plates pp. 78, 30) show naked bodies heaped up one upon the other. While the guard's intent may have been to humiliate the detainees by forcing them to participate in this ostensible gay orgy, the scene conjures a morbid and sinister event.

V.

Botero's cry of outrage expressed in the Abu Ghraib series is an attempt to help shift the attention of the public toward the timely and timeless issues of peace and humanity. Coming from an artist known for images of pleasure during a time of war and terror, the gruesome and violent scenes he depicts are exceptionally disturbing and moving. He joins a long line of artists who have passionately responded to tumultuous current events outside the rarefied ambiance of a successful artist's studio.

Formidable precedents in this arena include Géricault's 1819 *Raft of the Medusa* and Picasso's 1936 *Guernica*. Picasso's monumental anti-war statement reflects the devastation of the Spanish Civil War through the artist's abstract visual metaphors. There are also the potent examples of works by George Grosz, Otto Dix, and Max Beckmann, who conveyed in their expressionistic works an anguished opposition to war and injustice.

Botero's nightmarish vision is most closely allied with Goya's, in his powerful 1814 painting *The Third of May* and especially in the series of etchings titled "The Disasters of War." Following his satirical group of etchings "Los Caprichos," Goya applied his scathing critique of human foibles to an examination of the devastating consequences of military aggression. Not published until after the artist's death in 1828, the images focus on the 1814-18 uprising of the Spanish people against the French invaders. Goya, who witnessed some of the incidents he depicts firsthand and learned of others through spoken

and written accounts, shows the brutal savagery on both sides of the conflict. Unforgettable works such as *Great Deeds — Against the Dead*, a ghastly scene of dismembered corpses hanging in tree, and *Po rque?* (fig. 13), focusing on the senseless torture of a civilian, are among the most riveting anti-war images ever created. Several related drawings and etchings by Goya, including *Detention as Barbaric as the Crime* and *The Custody of a Criminal Does Not Demand Torture* (both 1810-20) (fig. 14), correspond closest of all to Botero's work.[9]

Goya's work remains a profound response to violence and cruelty in the world. Has Botero in his group of paintings and drawings sounded a comparable note of warning for our own times? It is certainly one of his most ambitious and thought-provoking endeavors. In offering art audiences his graphic portrayal of the horrific events that took place at Abu Ghraib, might he help to avert a similar madness from occurring in the future? By rubbing our noses in this tragic morass of human suffering, Botero obliges viewers to consider a number of questions of global importance today. Is violent retaliation the only way to stop and prevent acts of senseless violence, or do they merely beget even more violence, destruction, and death? Certainly, Botero, in his Abu Ghraib series, suggests that anyone with a sense of humanity must realize that fighting terrorist attacks with further acts of cruelty and terror is not the right solution.

I would like to thank a number of individuals for their help with this essay, especially Fernando Botero, Prestel editors Christopher Lyon and Peter Stepan, Tara Reddi of Marlborough Gallery, and Richard Vine, Marcia E. Vetrocq, Brian Wallis and Bruce Mundt. D.E.

[1] For detailed accounts of the investigation and prisoner testimonies see Mark Danner, *Torture and Truth: America, Abu Ghraib, and the War on Terror*, New York, New York Review of Books, 2004; also see Steven Strasser, ed., *The Abu Ghraib Investigations: the Official Reports of the Independent Panel and the Pentagon on the Shocking Prisoner Abuse in Iraq*, New York, Public Affairs, 2004.

[2] "Fernando Botero: The Past 15 Years" at the Palazzo Venezia, Rome, June 17–September 25, 2005; and "Fernando Botero," Kunsthalle Würth, Schwäbisch Hall, November 11, 2005–April 17, 2006.

[3] Dr. Wibke von Bonin, "An Interview with Fernando Botero," Marlborough Gallery exhibition catalogue, 1972, pp. 9-10.

[4] Carter Ratcliff, *Botero*, Abbeville, New York, 1980, p. 27. Ratcliff credits artist and critic Scott Burton with coining this term.

[5] Juan O. Tamayo, "Artist Portrays Violence in Colombia, Stirs Feelings," *The Miami Herald*, July 24, 2000.

[6] This and following quote from Botero's e-mail correspondence with the author, June 6, 2006.

[7] "Colombian Artist Depicts Abu Ghraib Abuse" by Dan Molinski, *Associated Press*, April 12, 2005.

[8] "Inconvenient Evidence: Iraqi Prison Photographs from Abu Ghraib," organized by International Center of Photography director and chief curator Brian Wallis, appeared at the ICP, September 17–November 28, 2004, and at the Andy Warhol Museum, Pittsburgh, September 11–November 28, 2004.

[8] See Xavier de Salas, *Goya*, Milan and New York, Mayflower/Arnold Mondadori, 1981, p. 123.

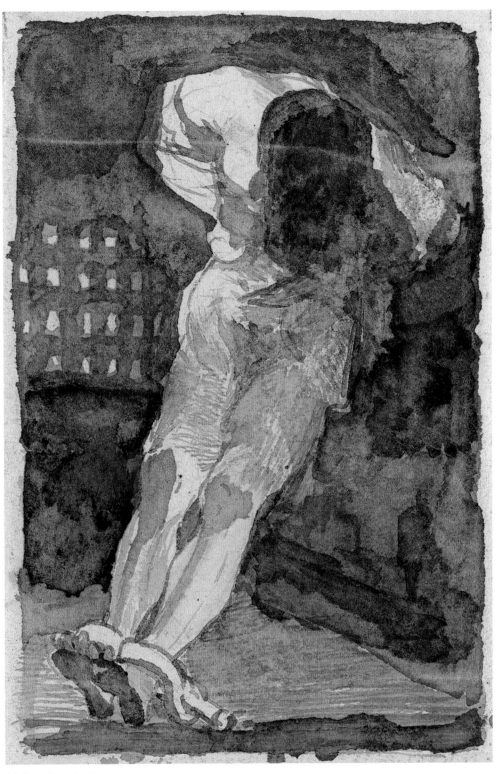

14 Francisco de Goya
La Seguridad de un reo no exige tormento (The Custody of a Criminal Does Not Demand Torture), drawing, 1810-14, Museum of Fine Arts, Boston

ABU GHRAIB

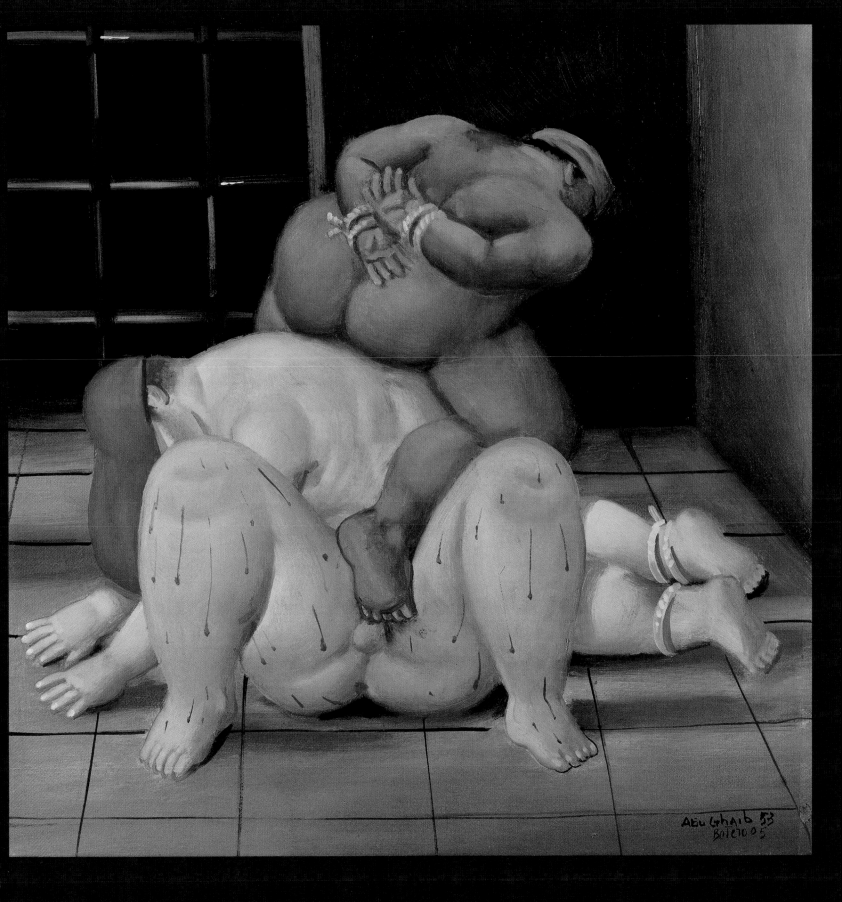

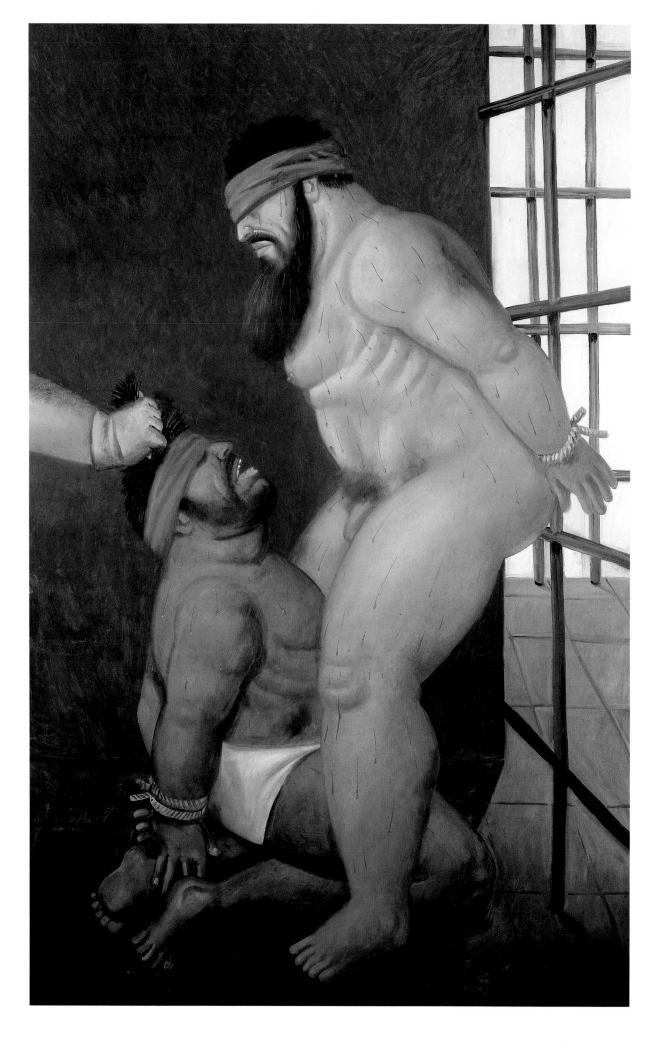

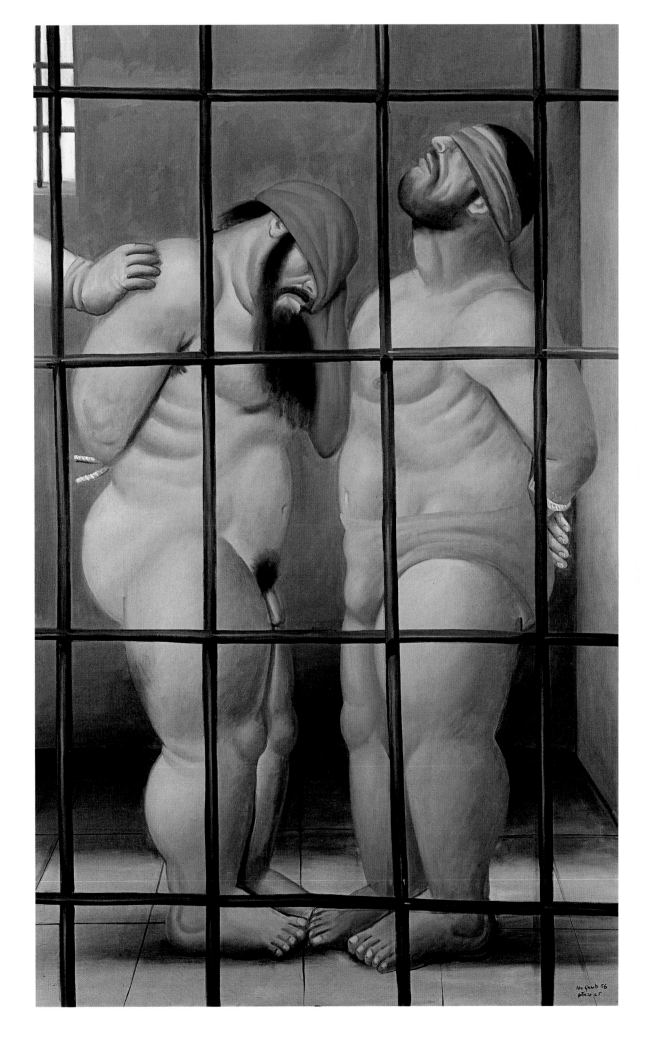

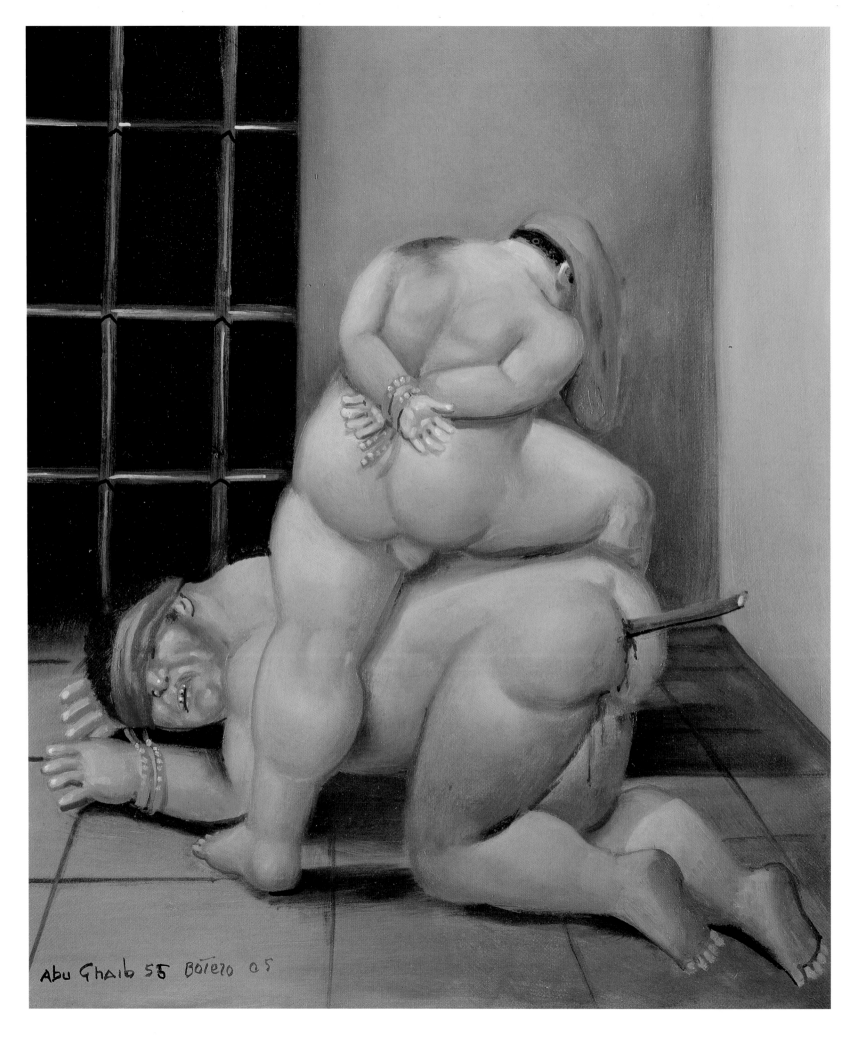

Abu Ghaib 55 Botero 05

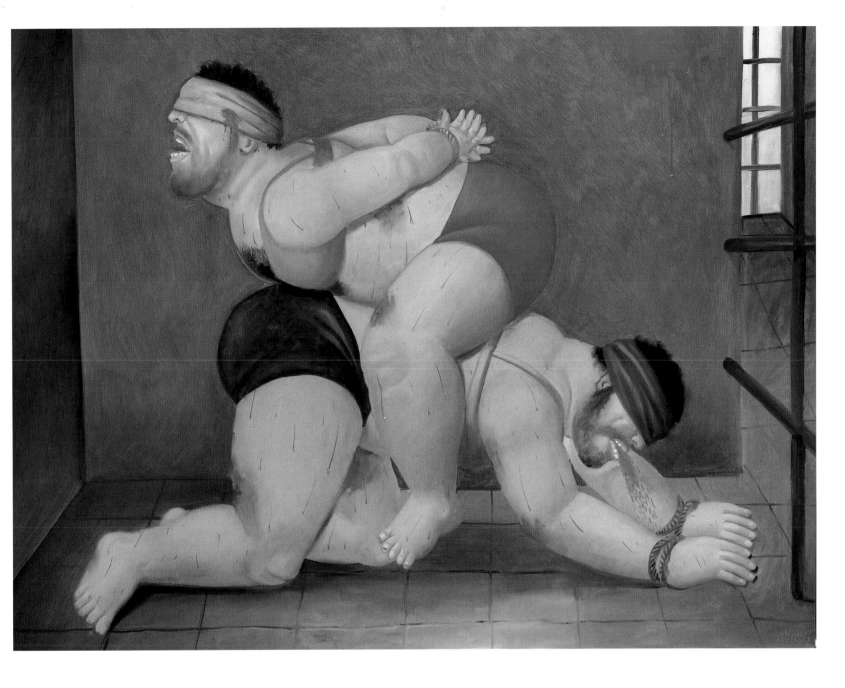

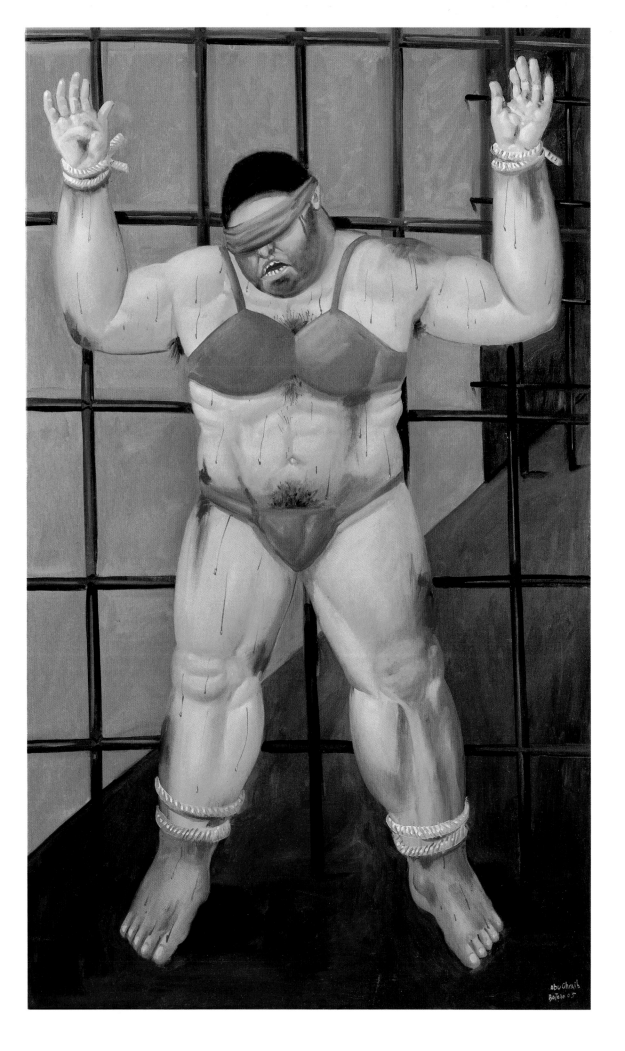

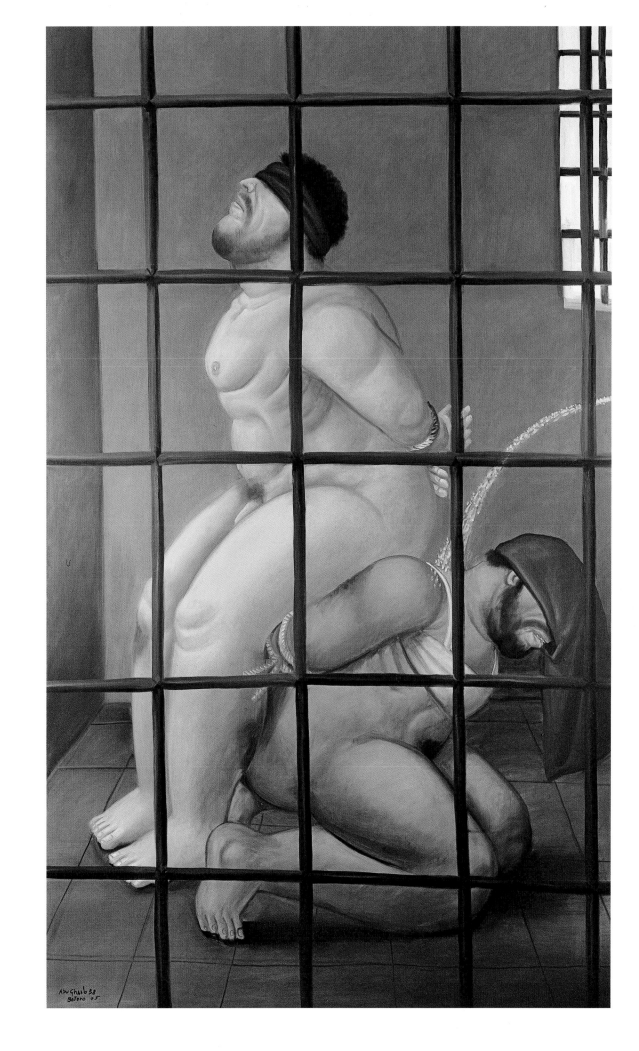

Abu Ghraib 58
Botero 05

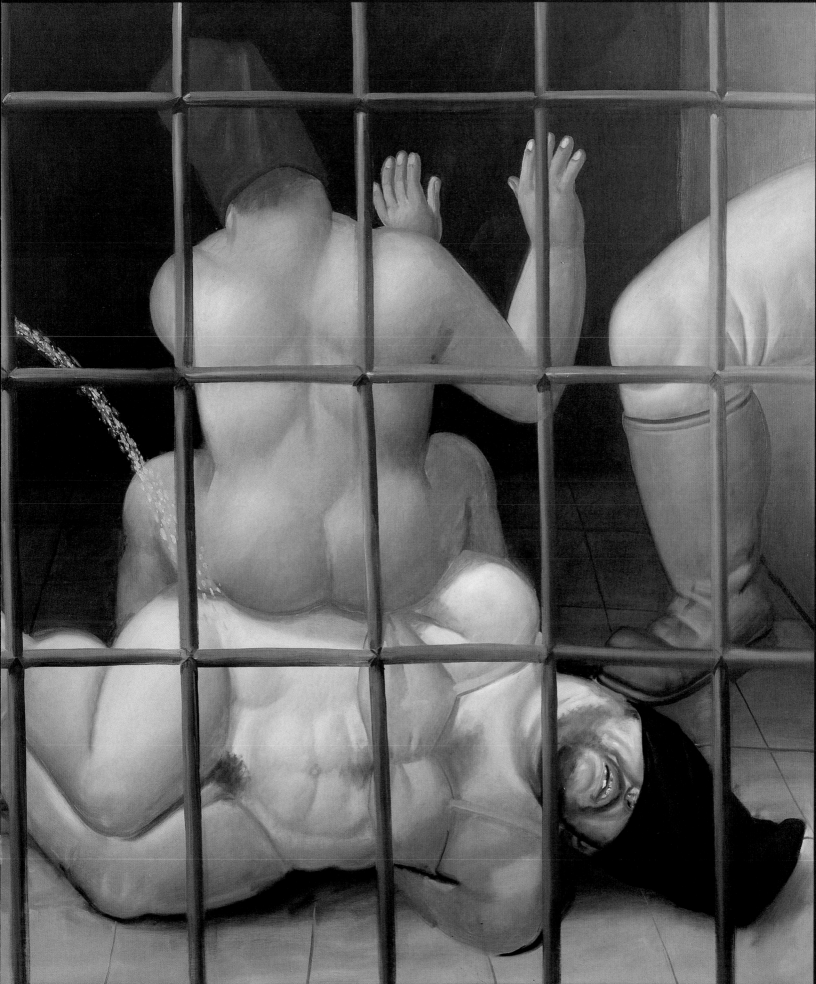

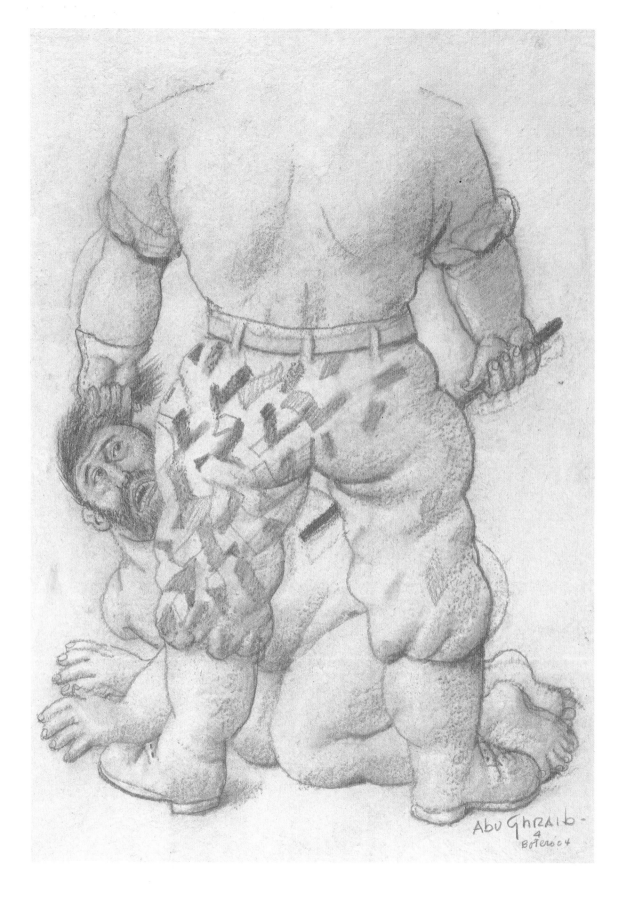

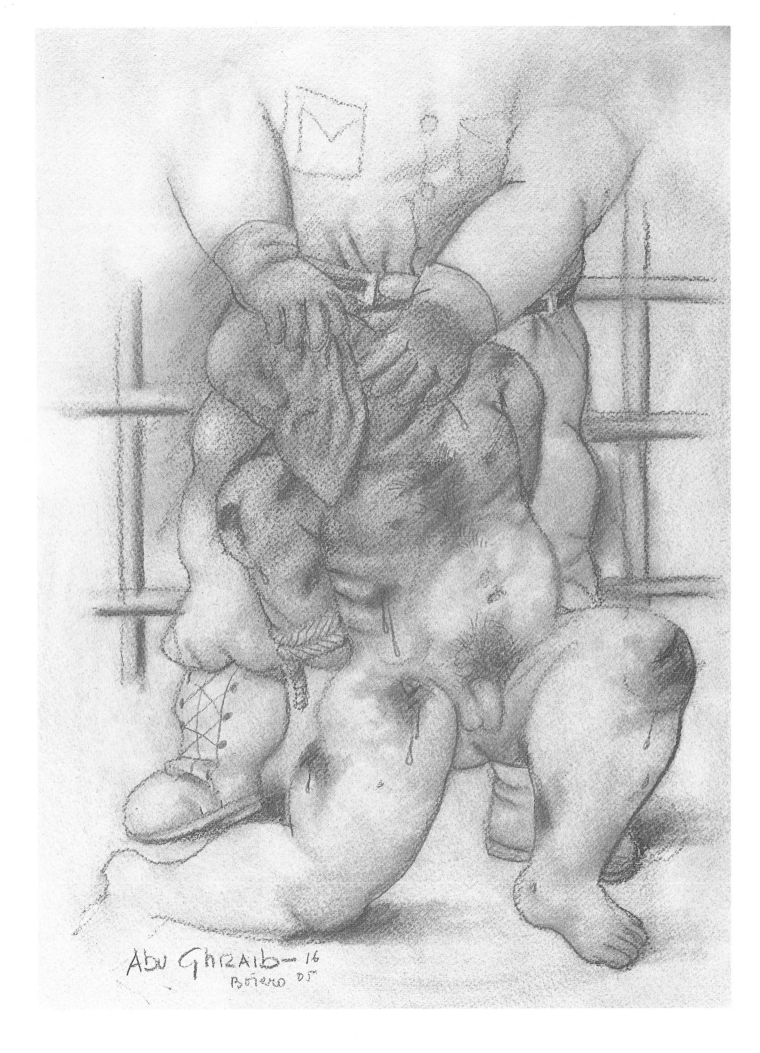

Abu Ghraib – 16
Botero 05

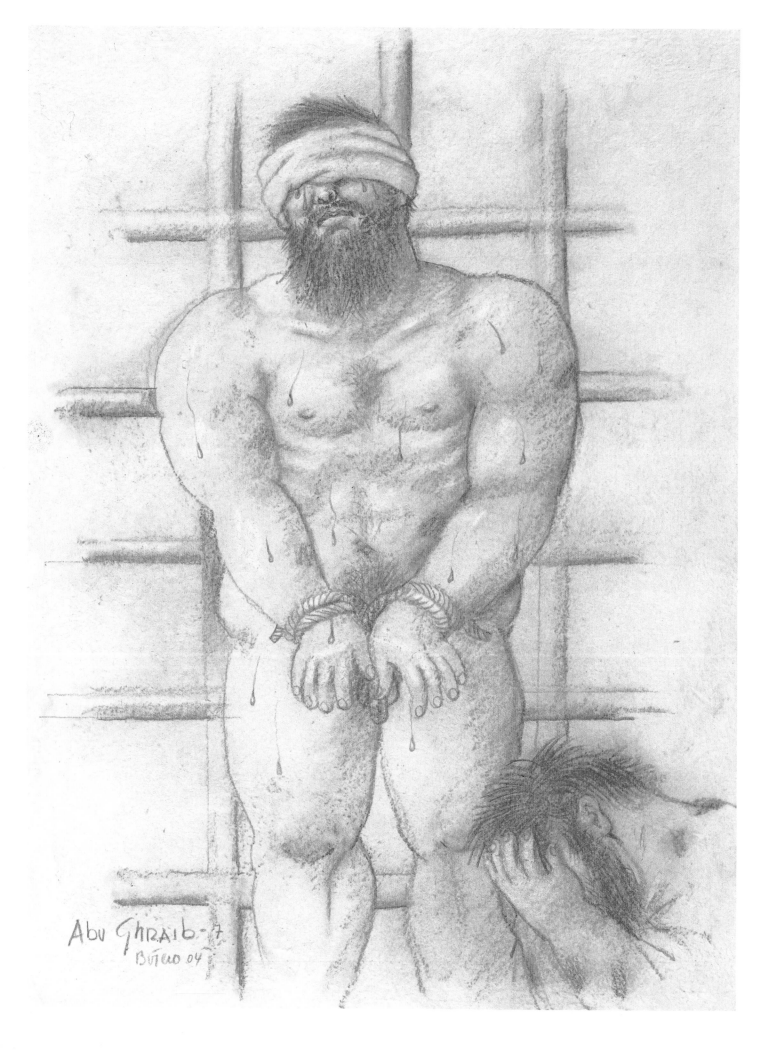

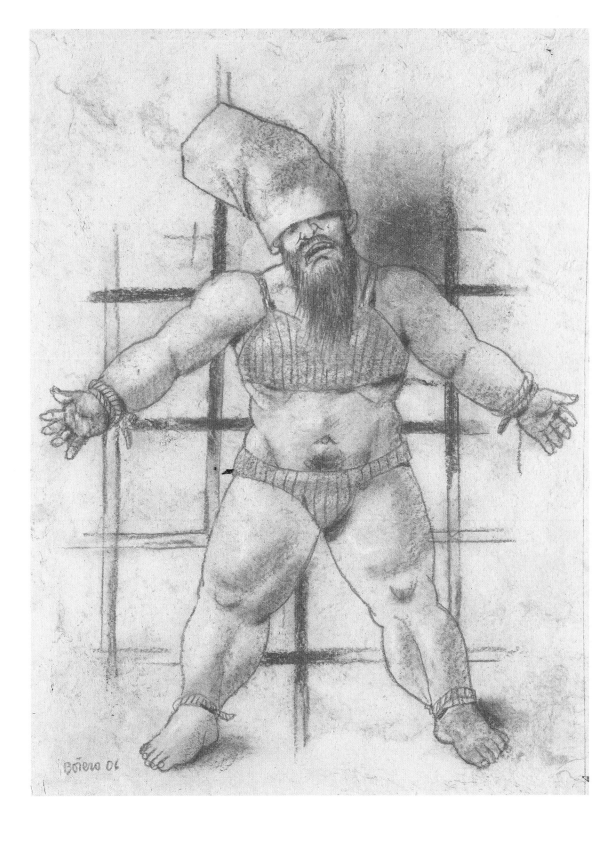

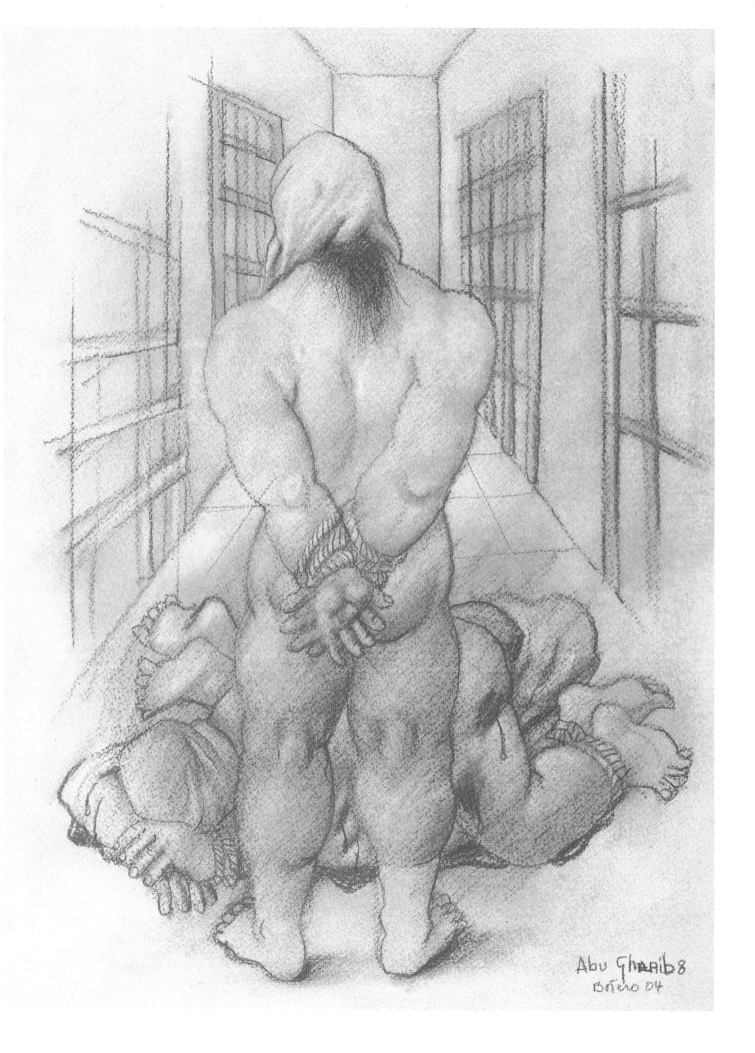

Abu Ghraib 8
Botero 04

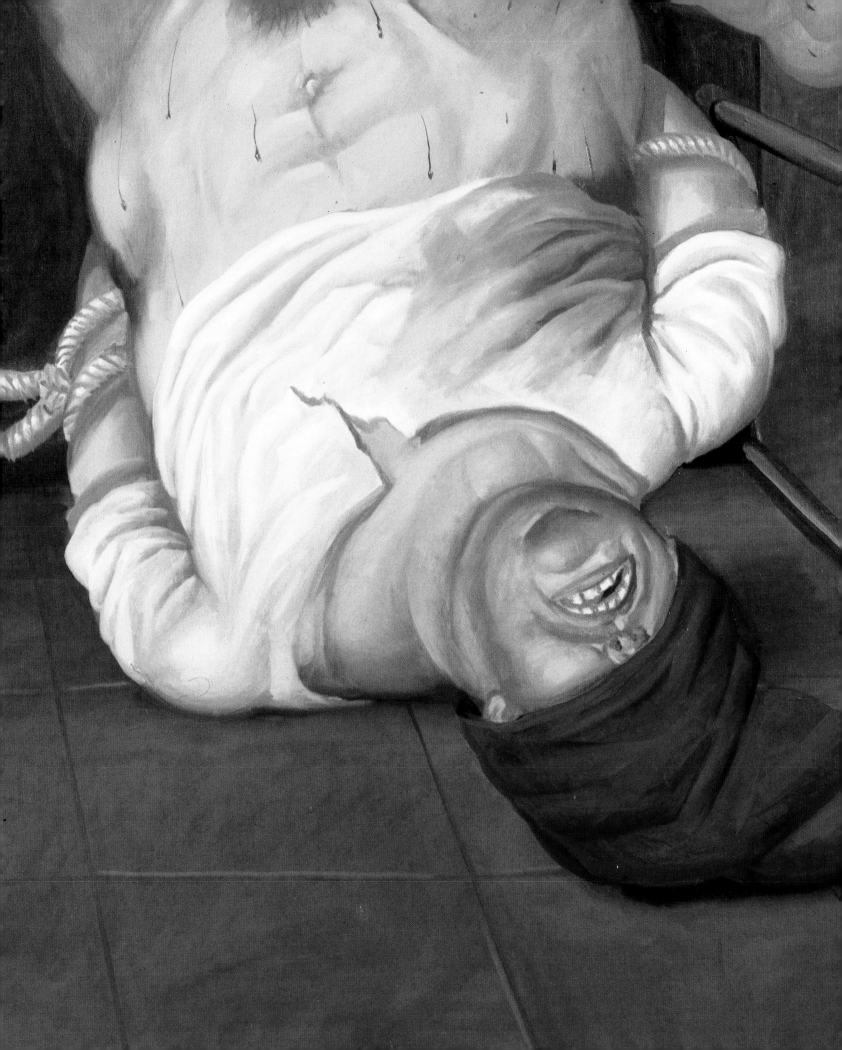

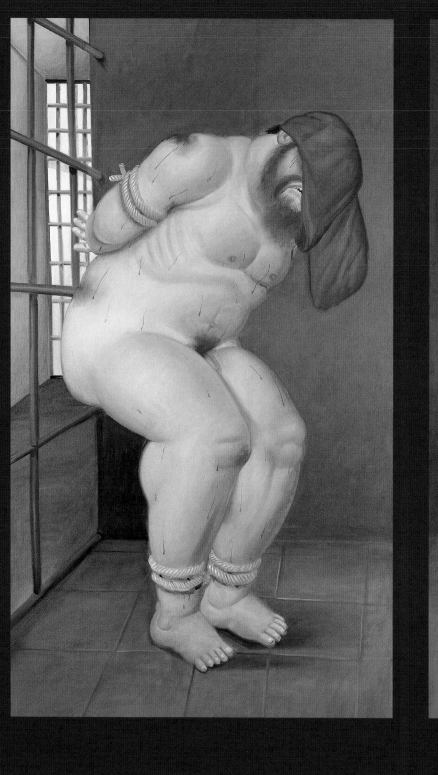
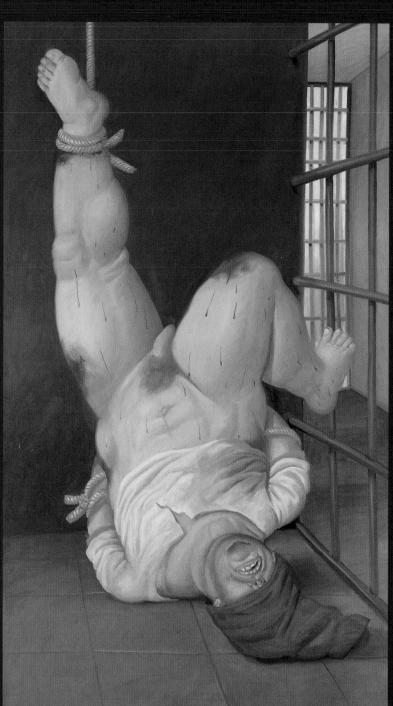

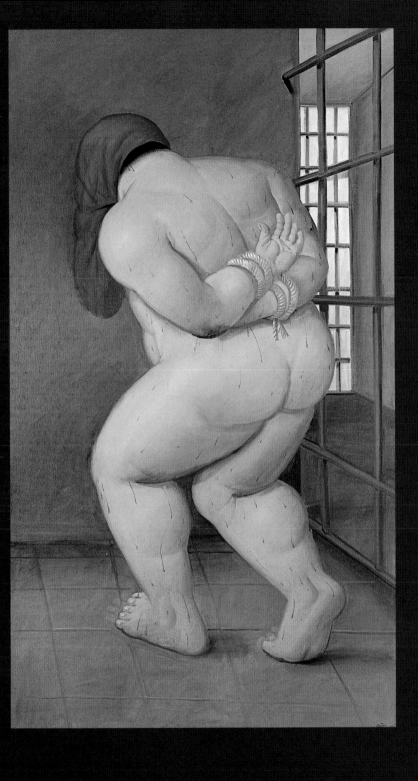

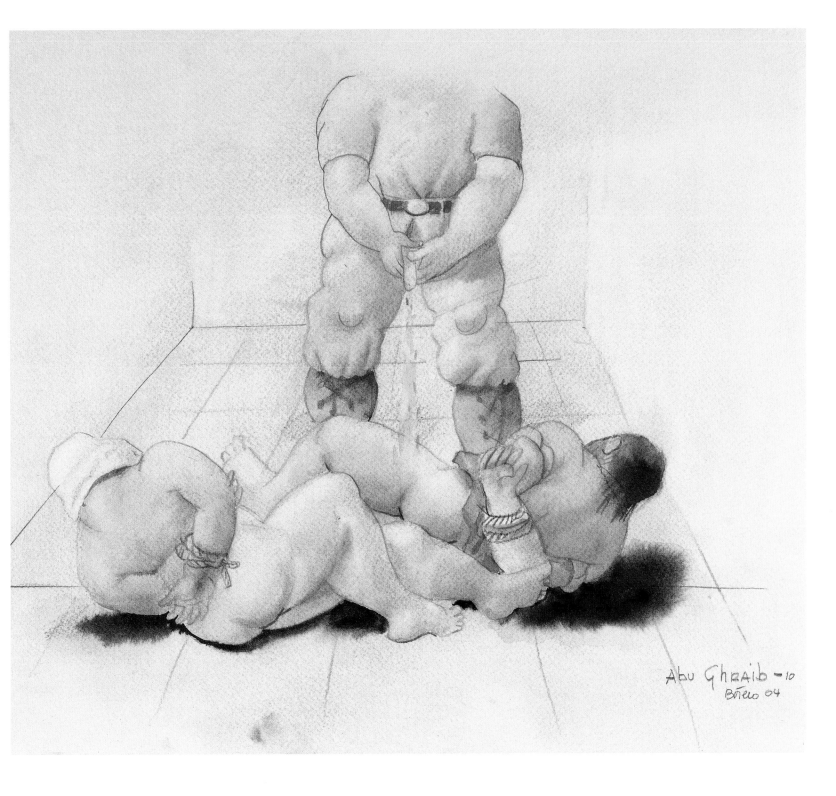

Abu Ghraib - 10
Botero 04

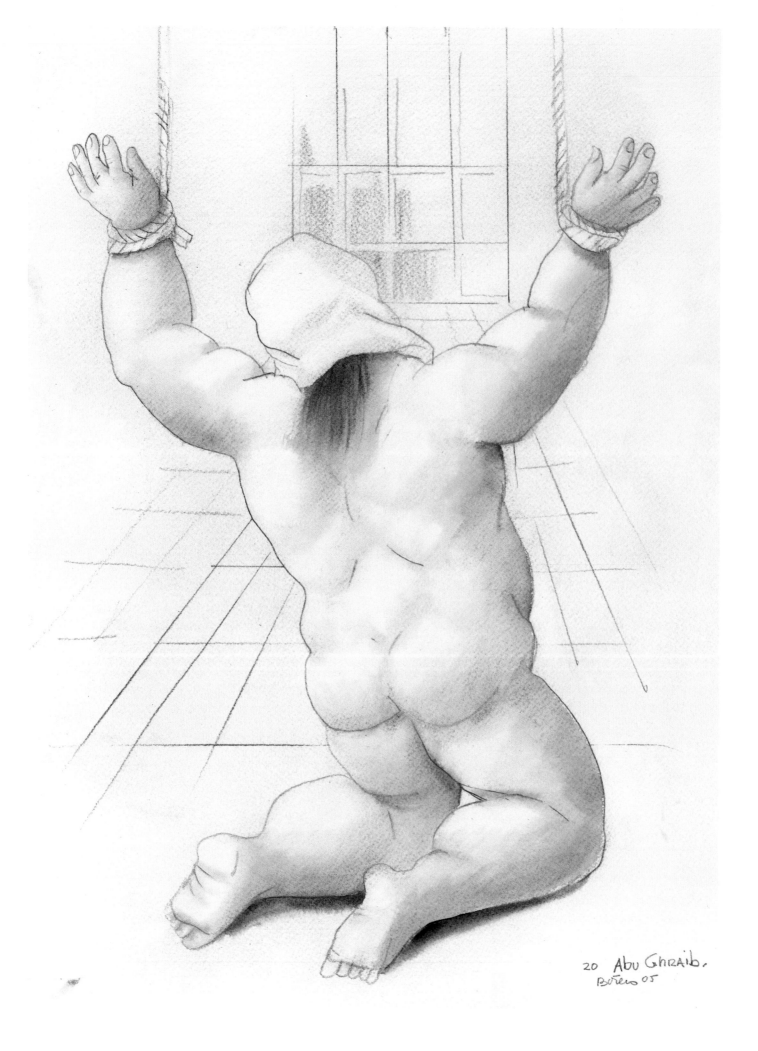

20 Abu Ghraib.
Botero 05

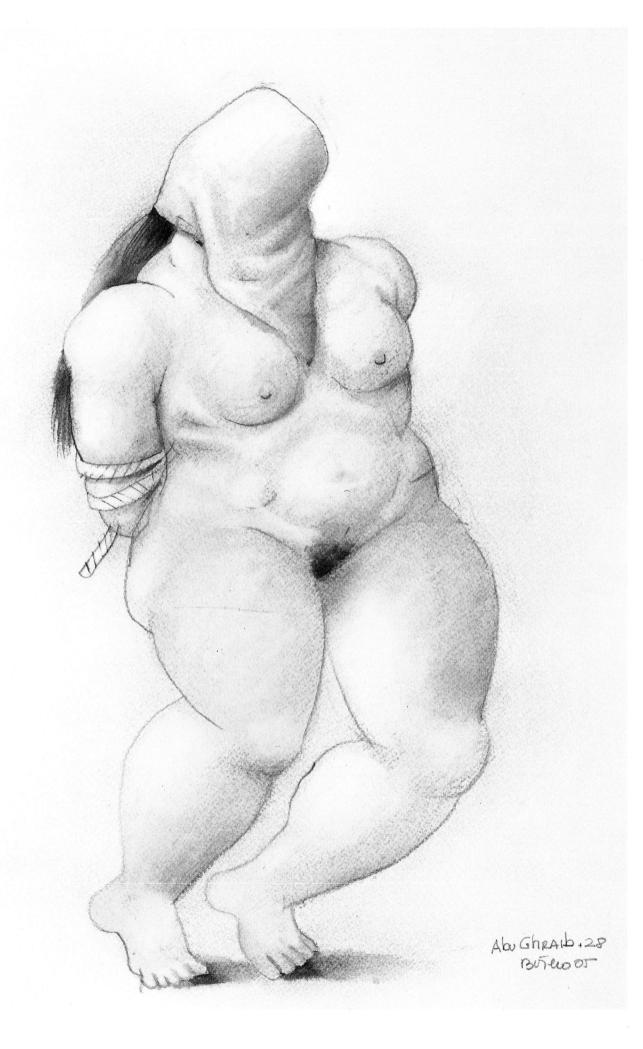

Abu Ghraib . 28
Botero 05

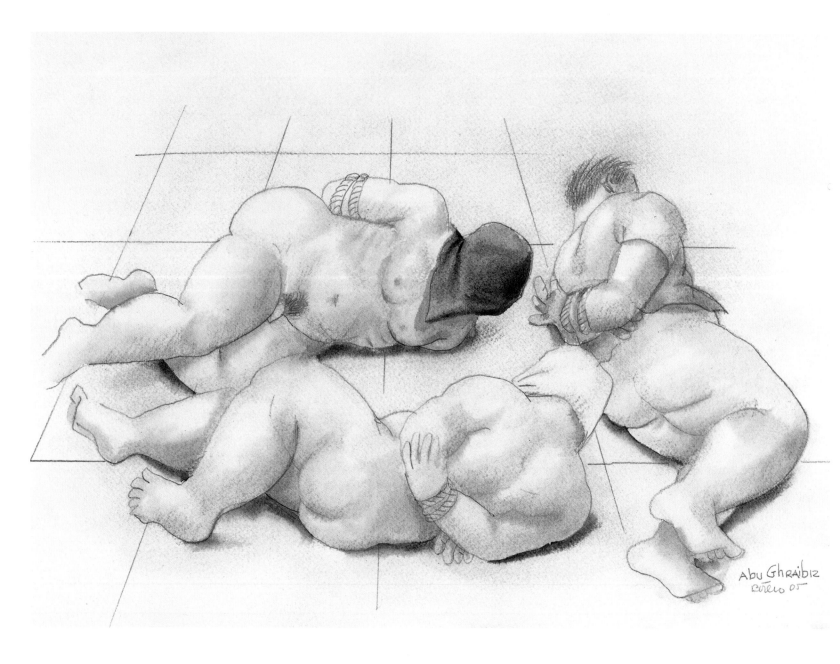

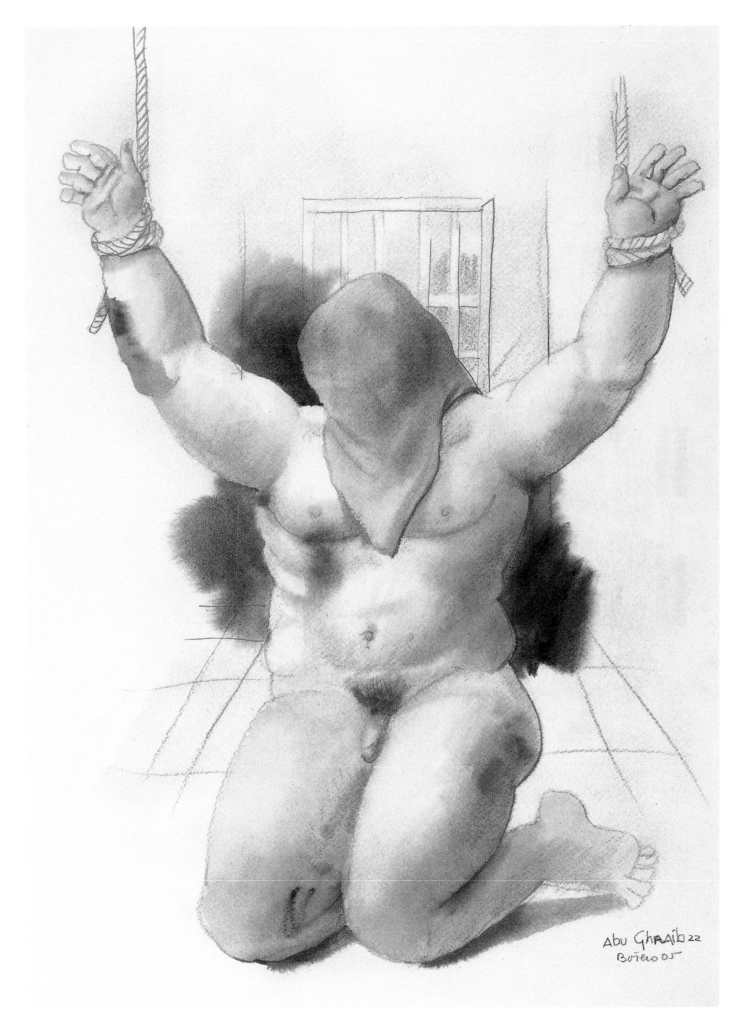

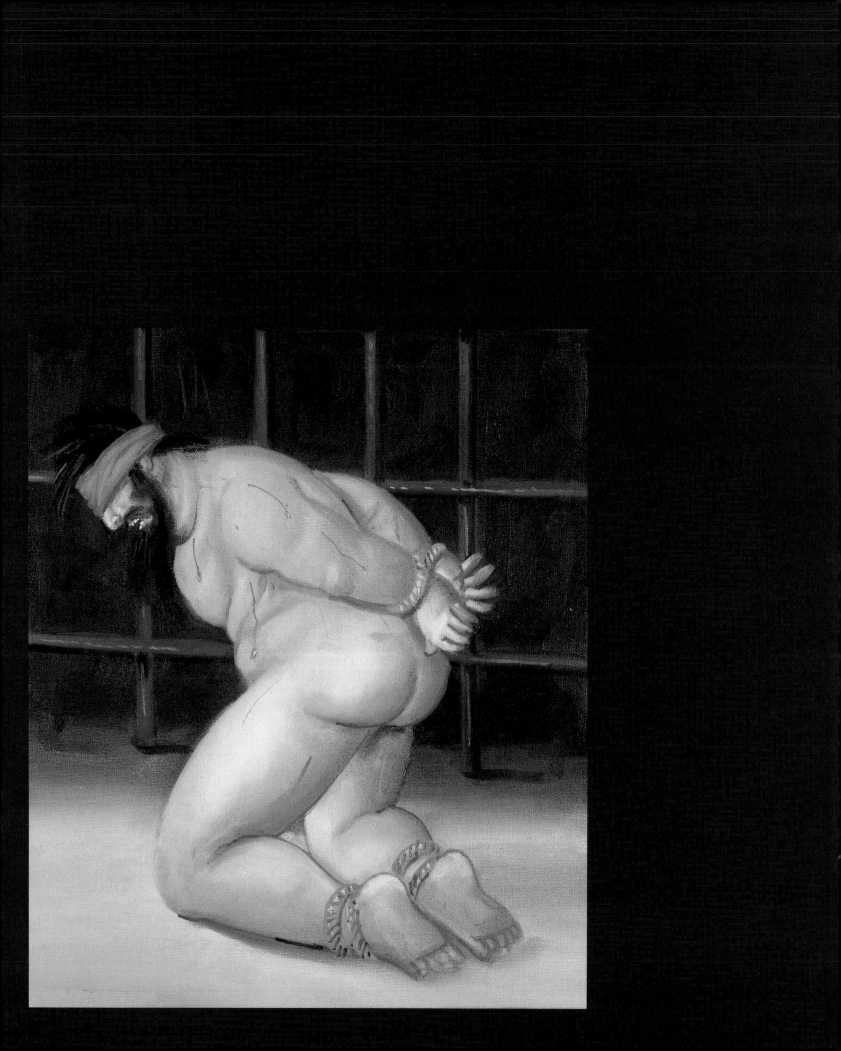

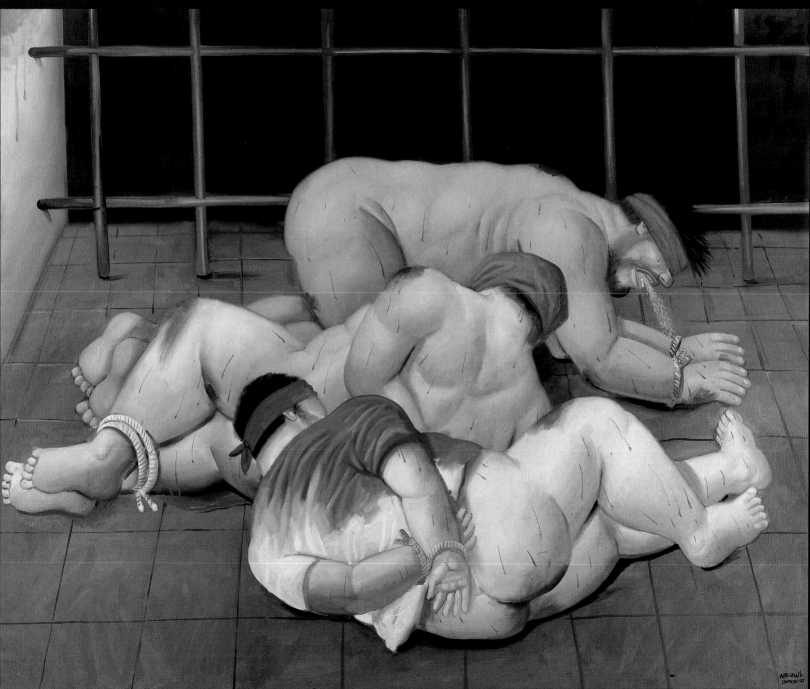

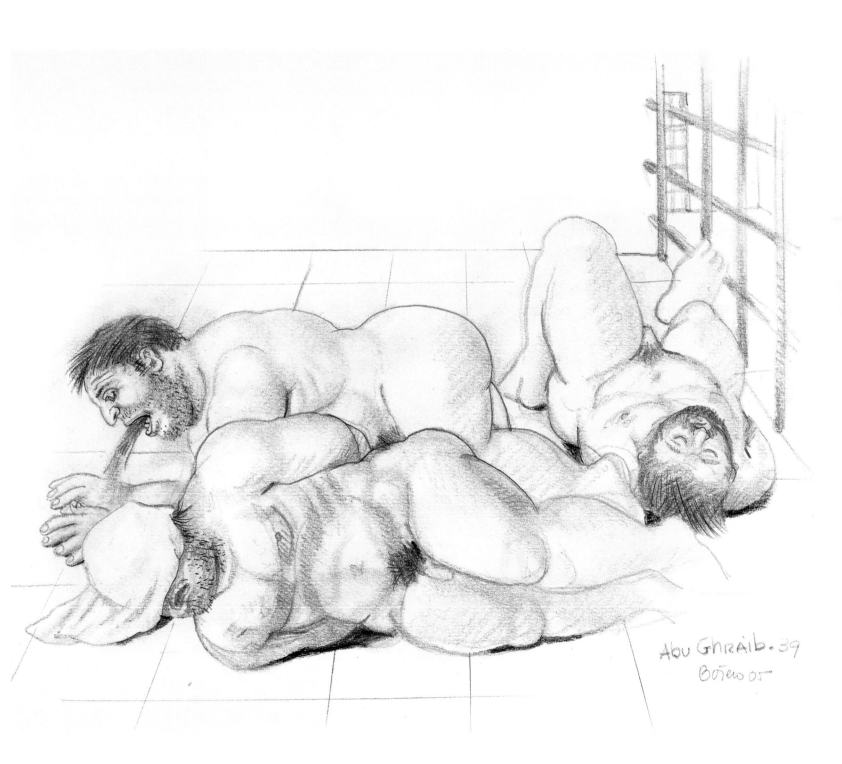

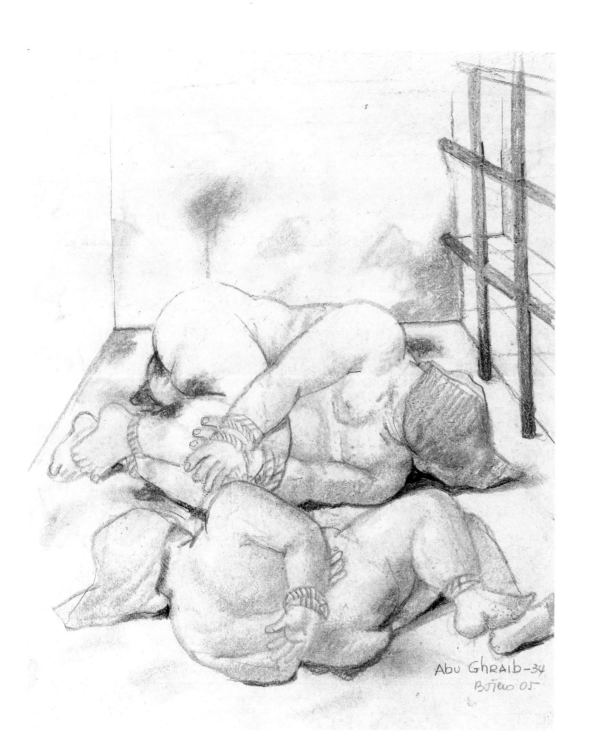

Abu Ghraib-34
Botero 05

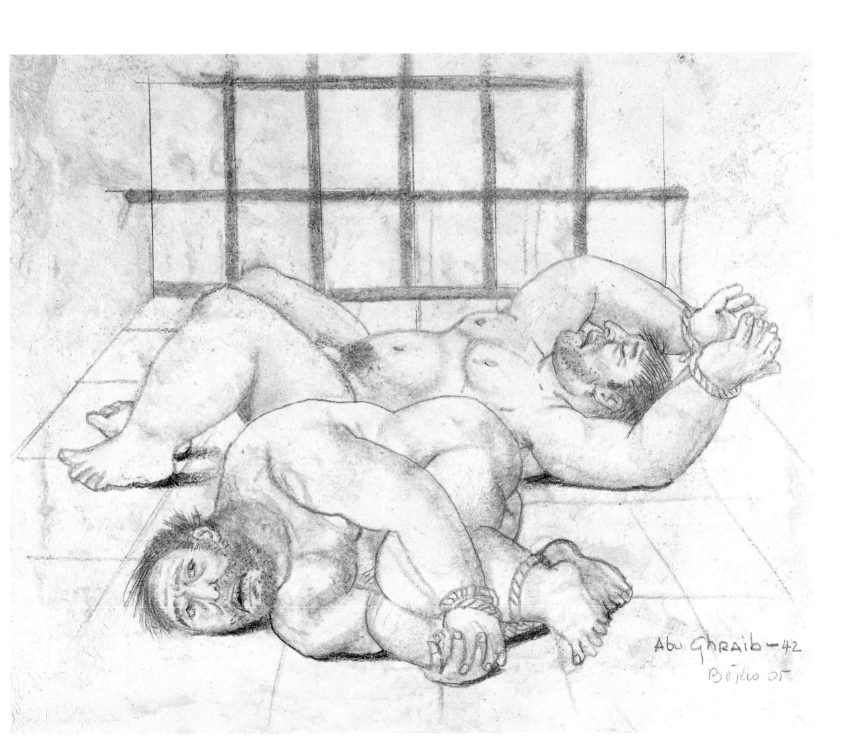

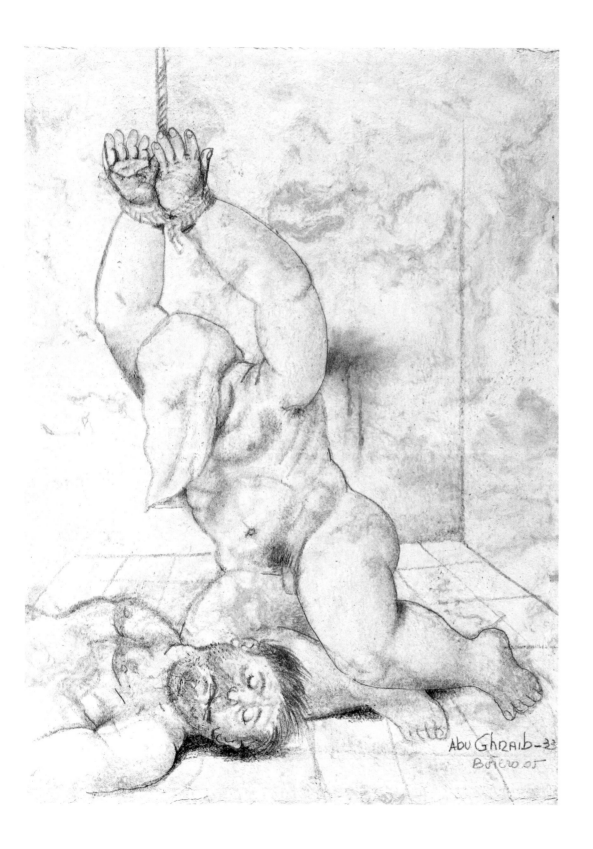

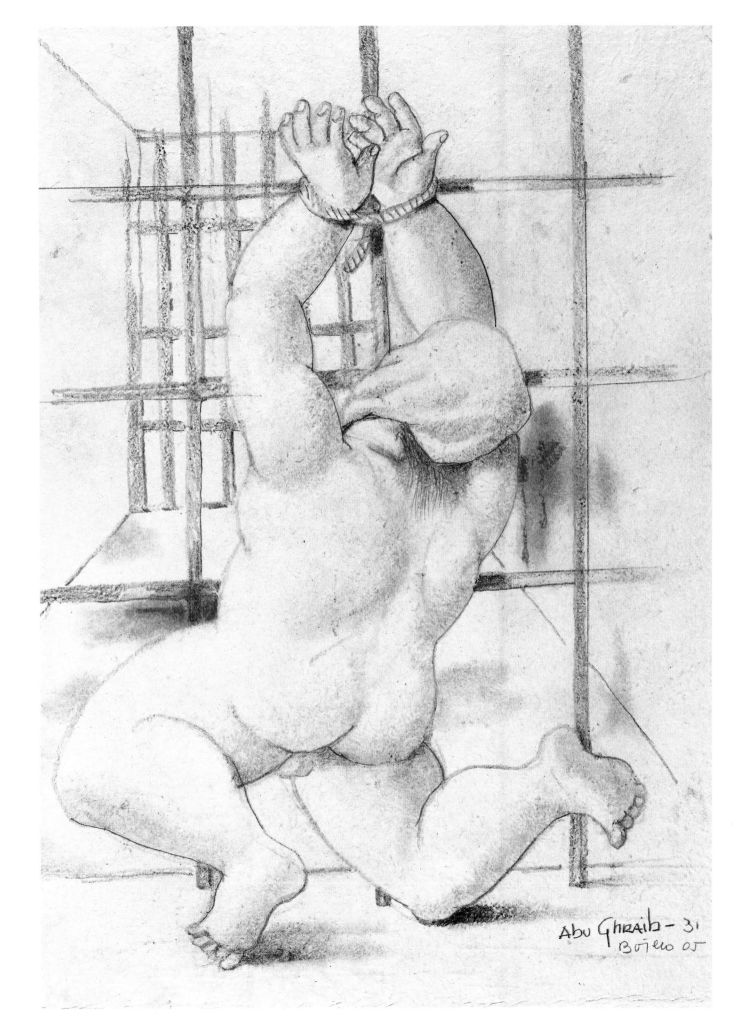

Abu Ghraib – 31
Botero 05

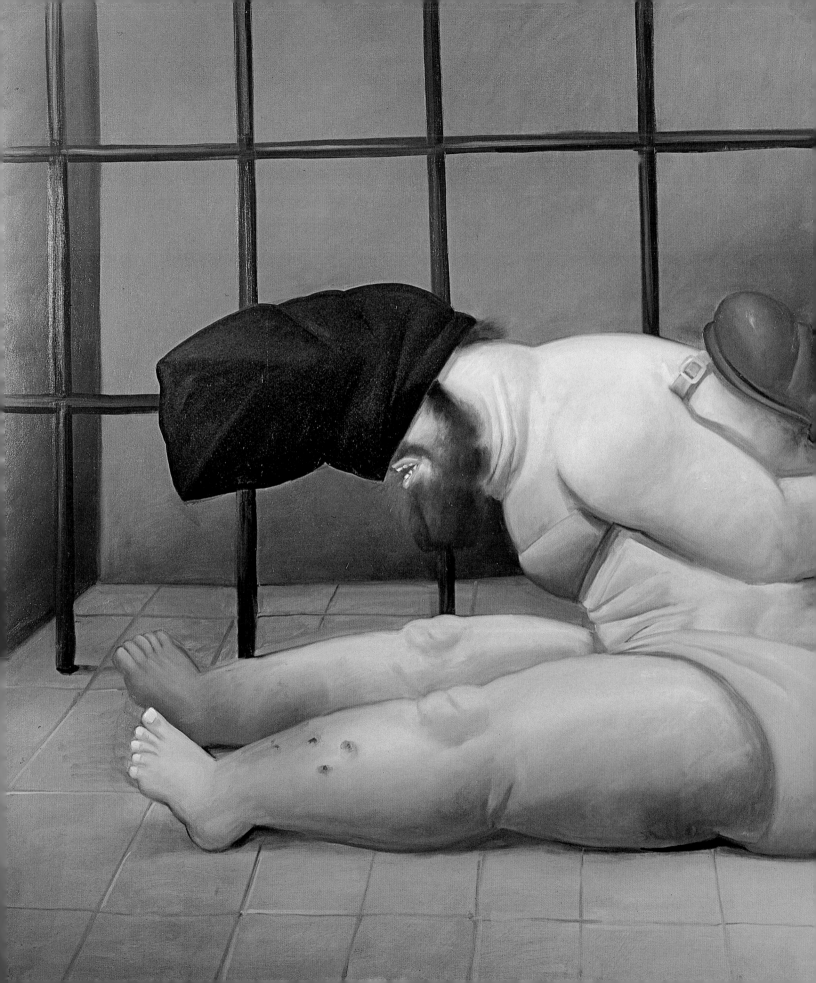

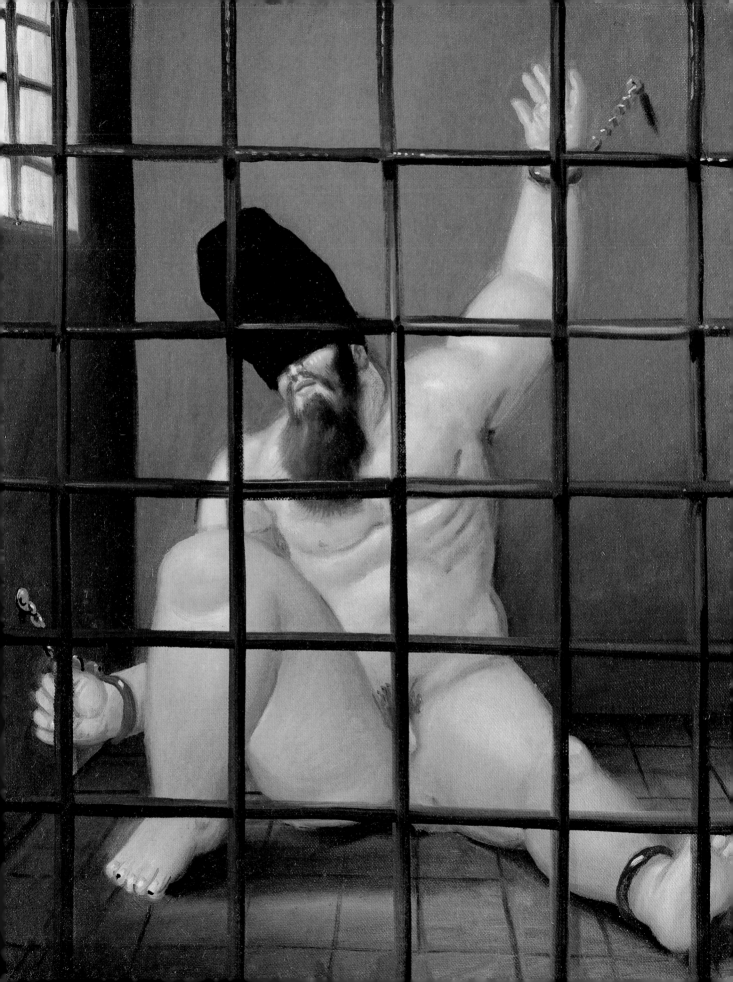

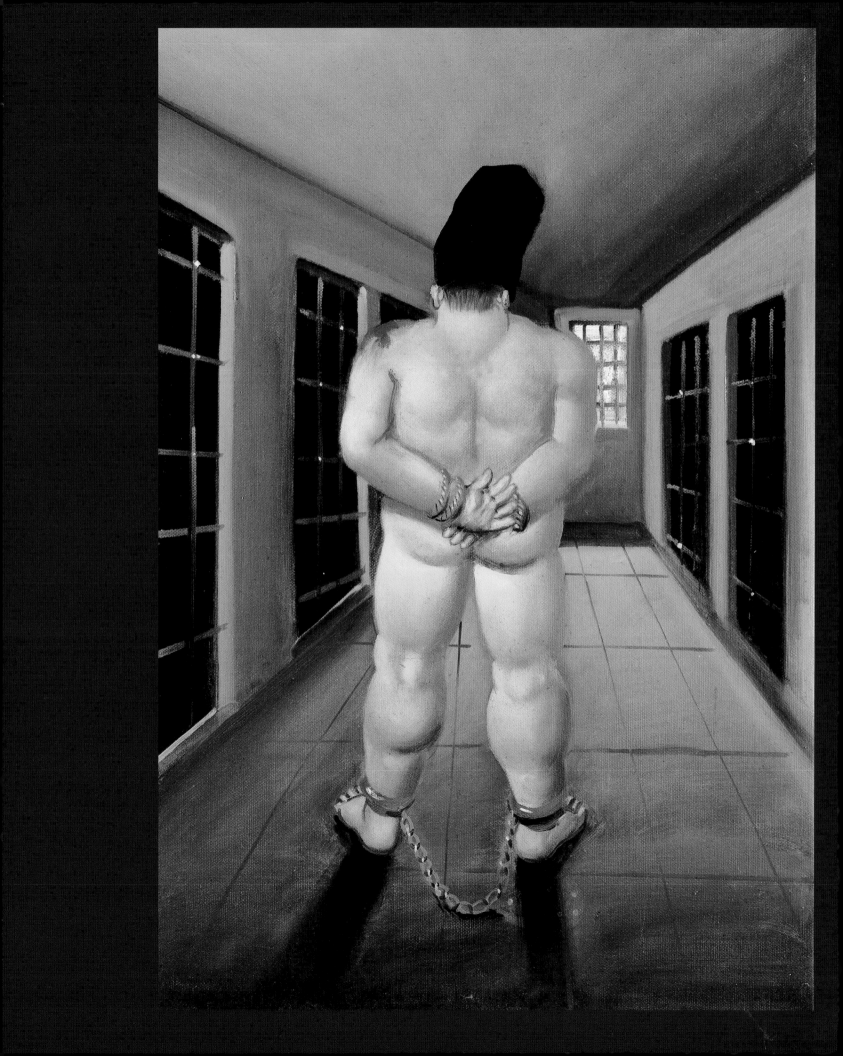

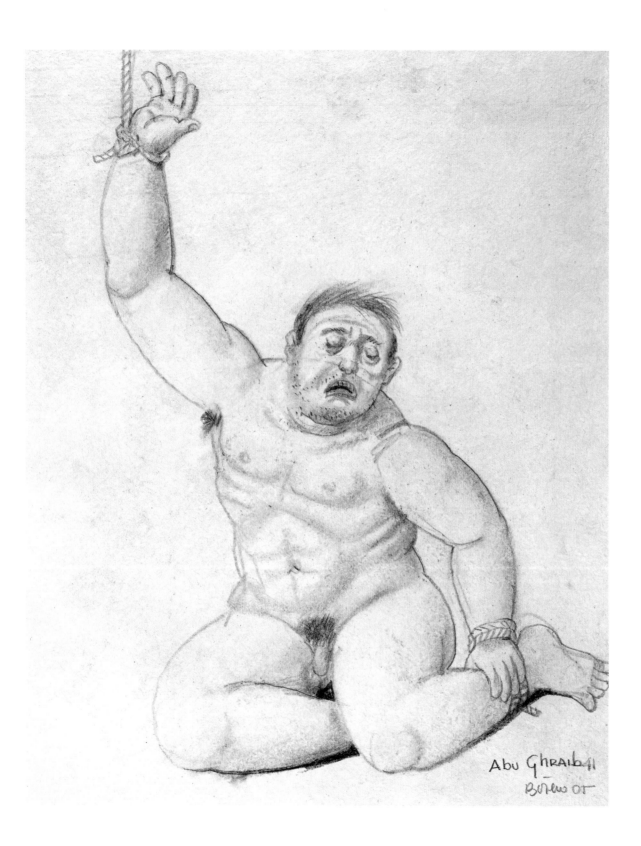

Abu Ghraib 41

Botero 05

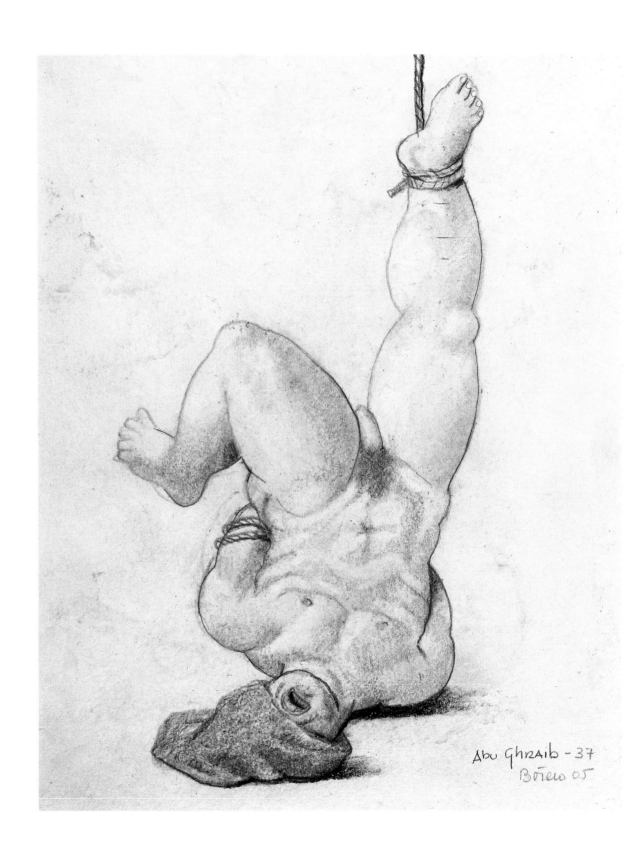

Abu Ghraib - 37
Botero 05

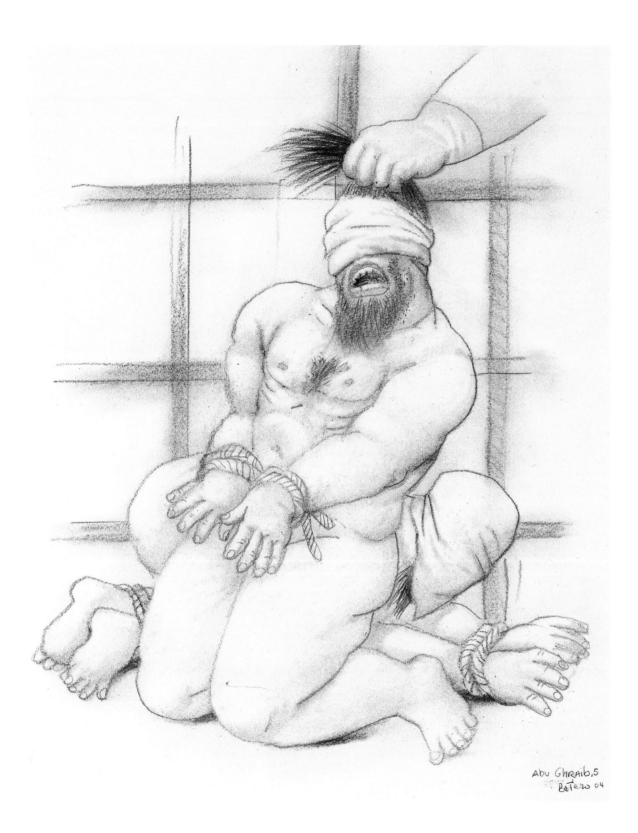

Abu Ghraib, 5
Botero 04

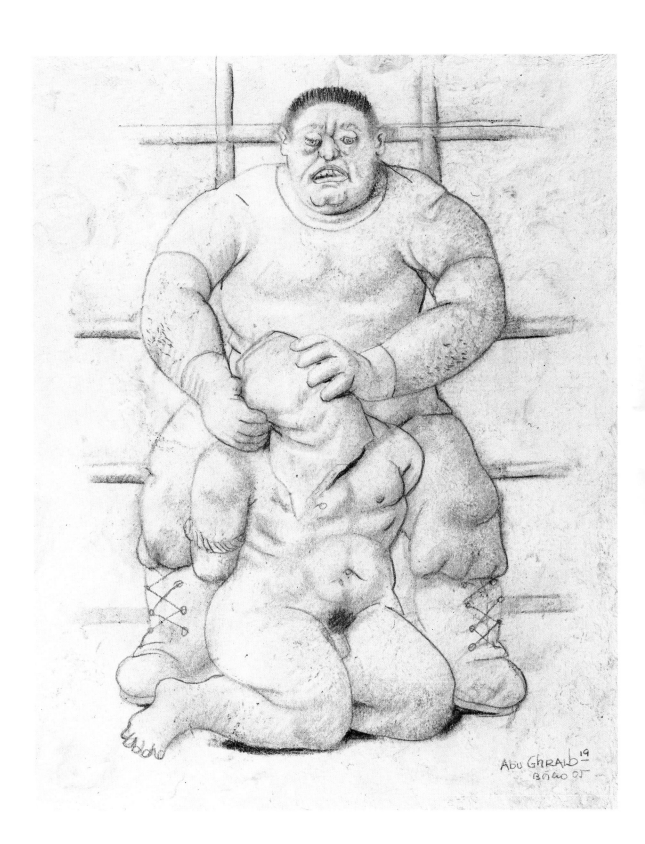

Abu GHRAIB 19
BflRO 05

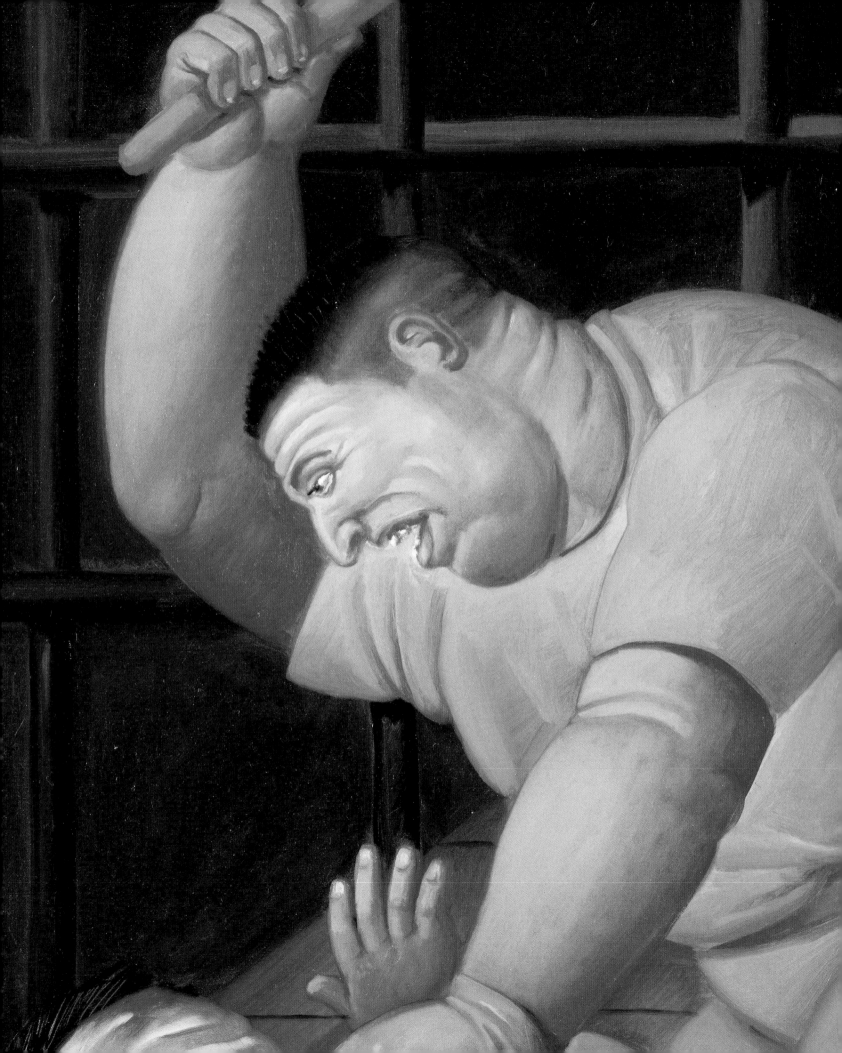

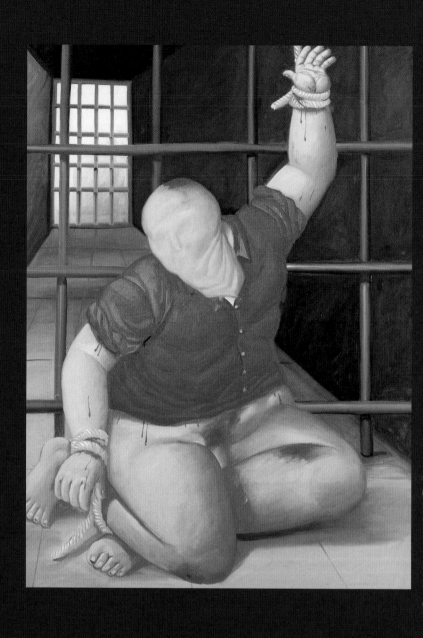

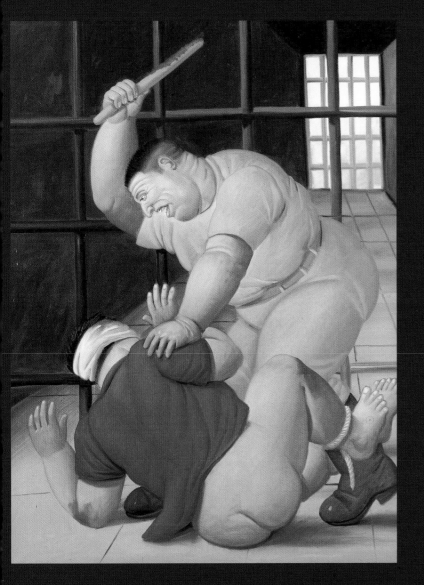
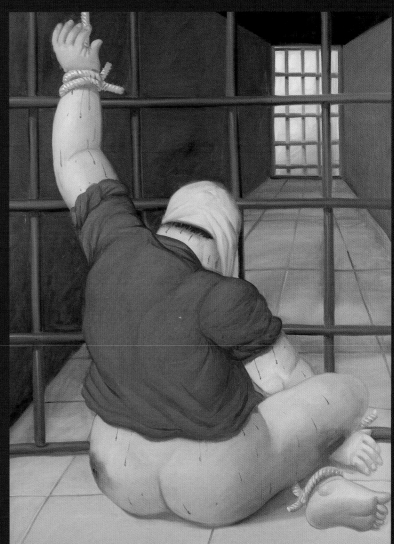

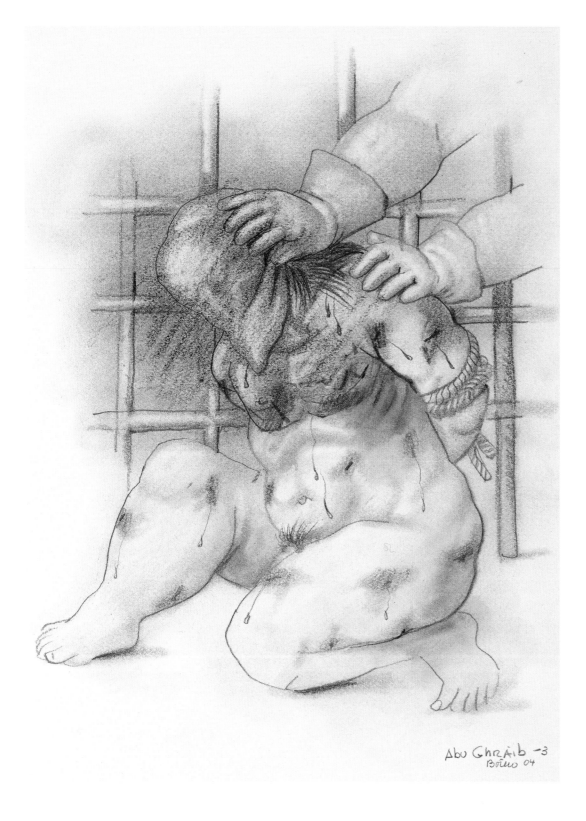

Abu Ghraib -3
Botero 04

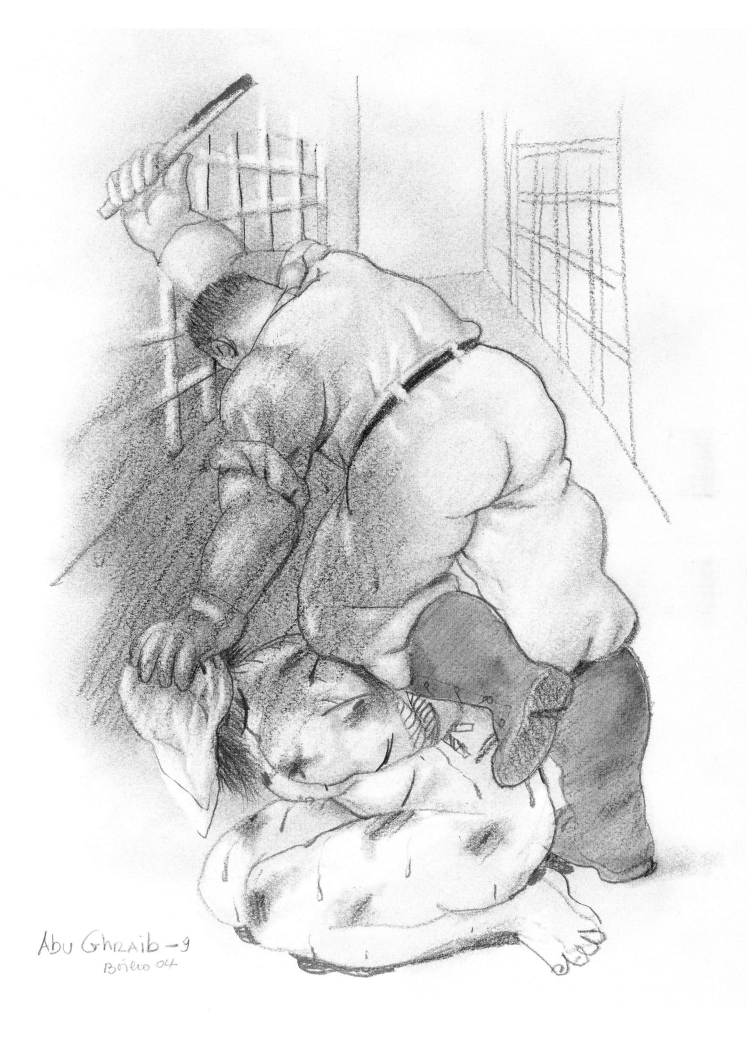

Abu Ghraib -9
Botero 04

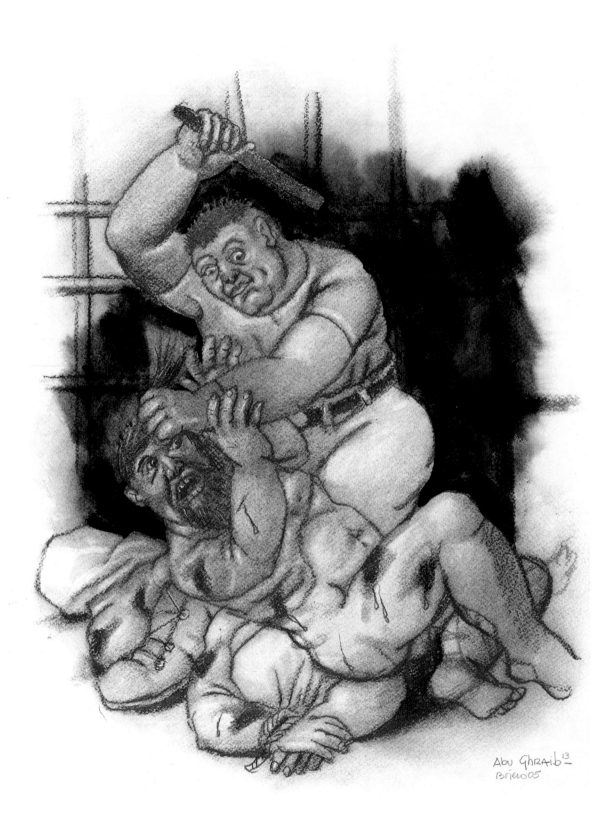

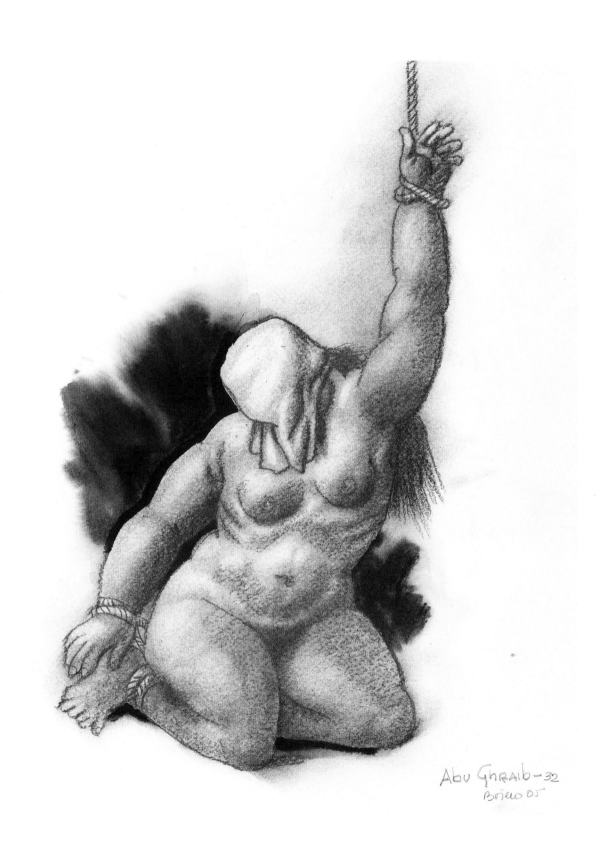

Abu Ghraib-32
Botero 05

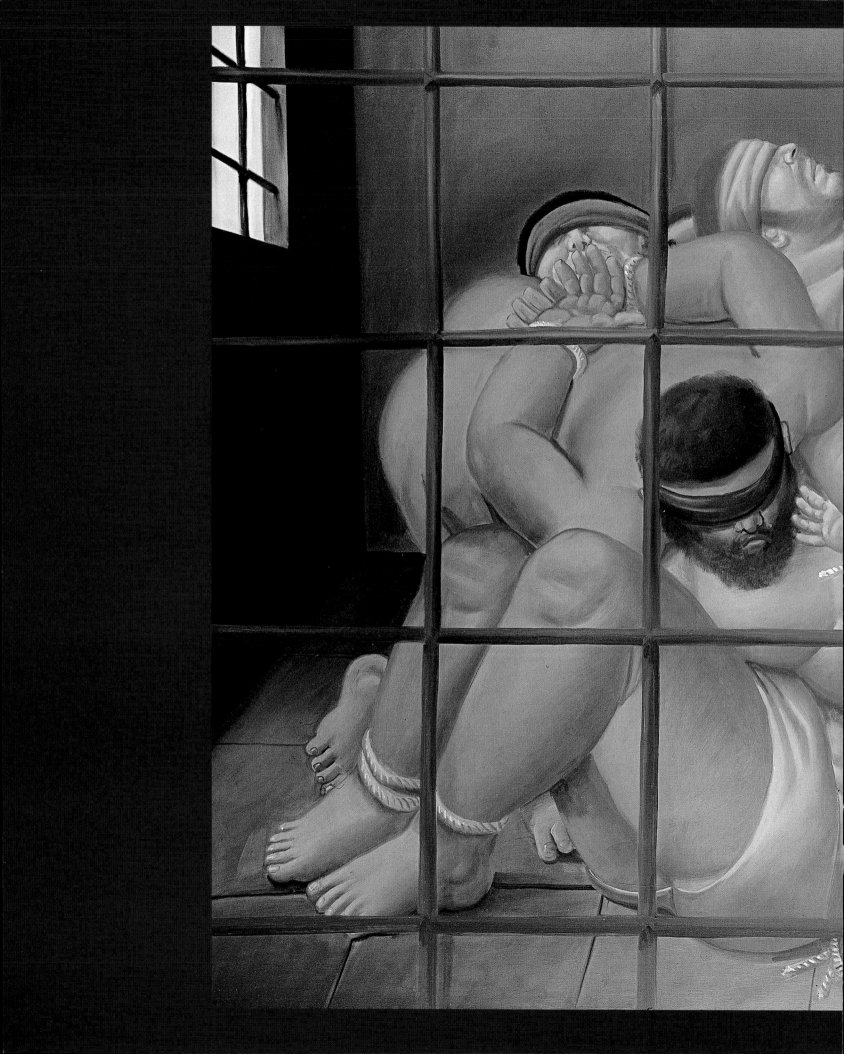

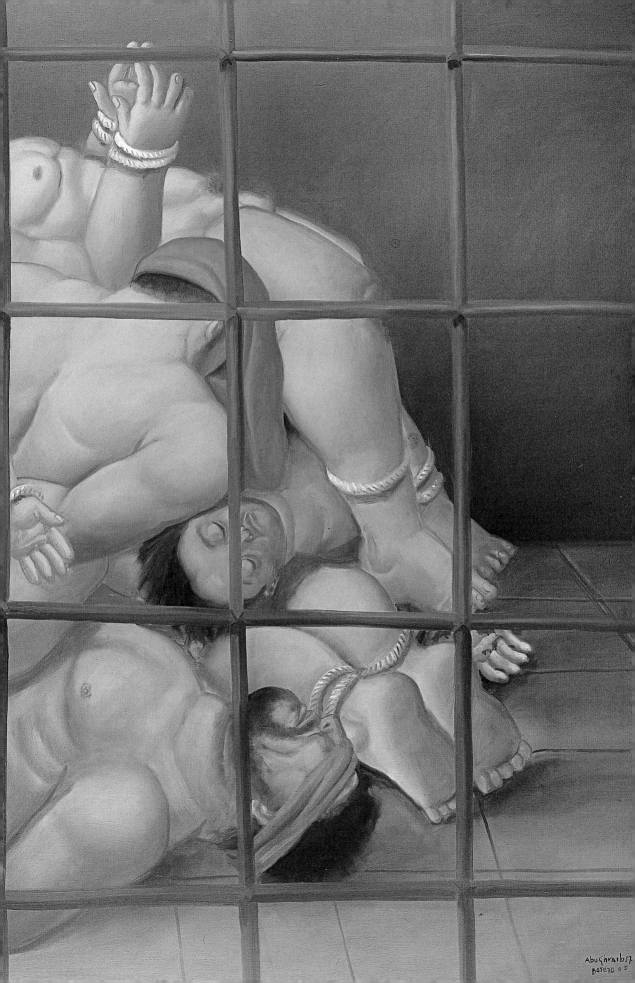

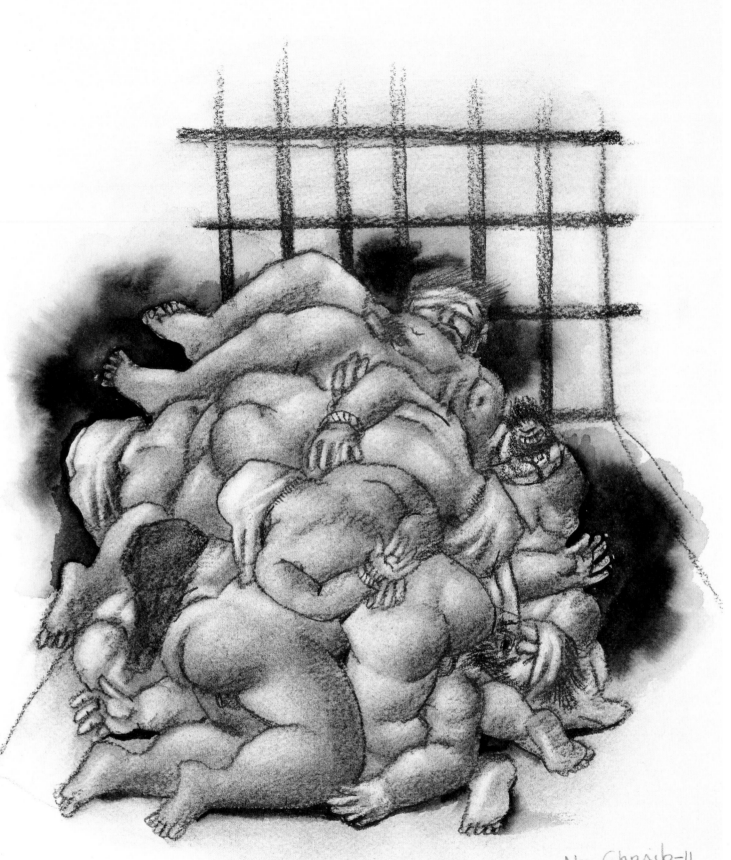

Abu Ghraib-11
Botero 04

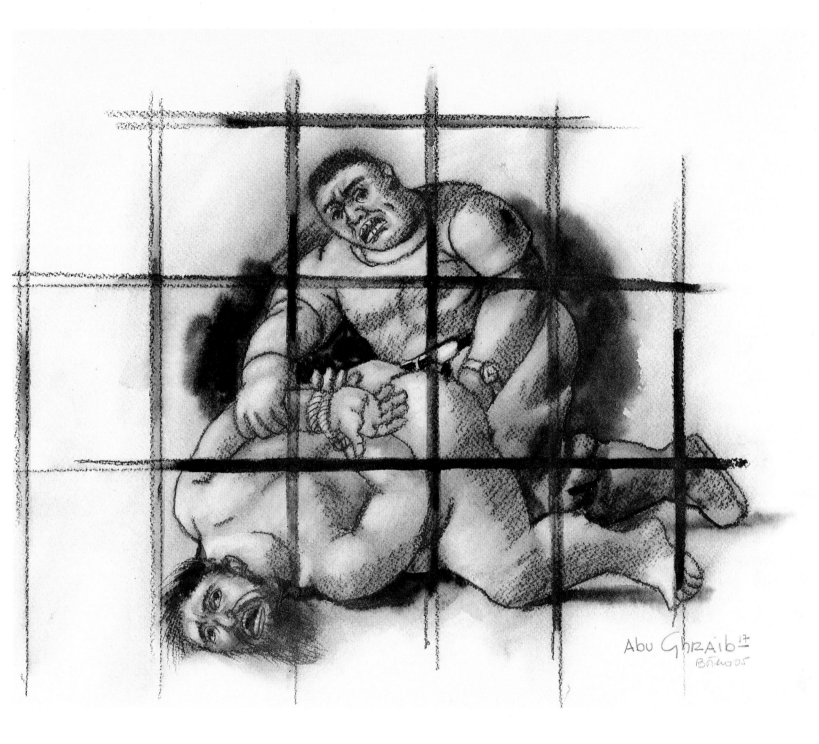

Abu Ghraib
BTW005

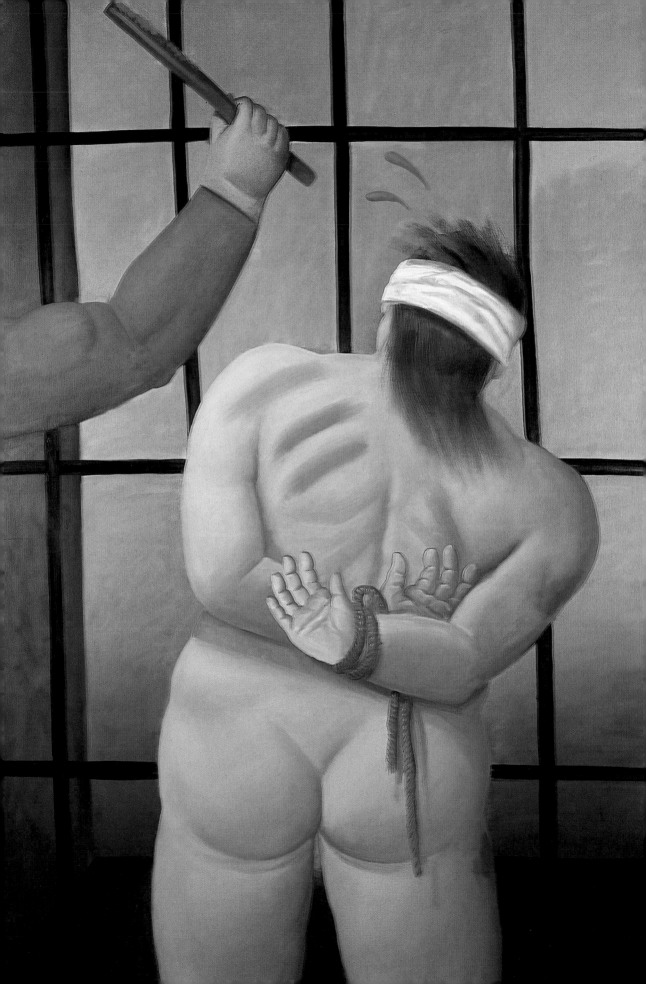

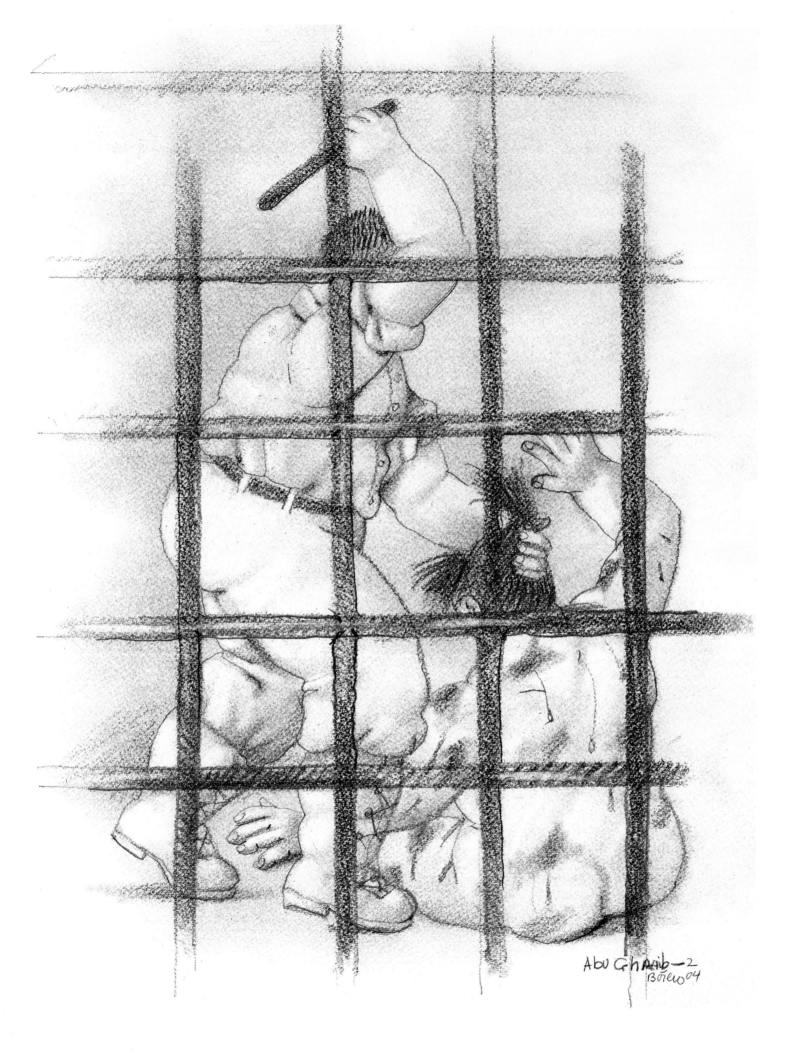

Abu Ghraib-2
Botero 04

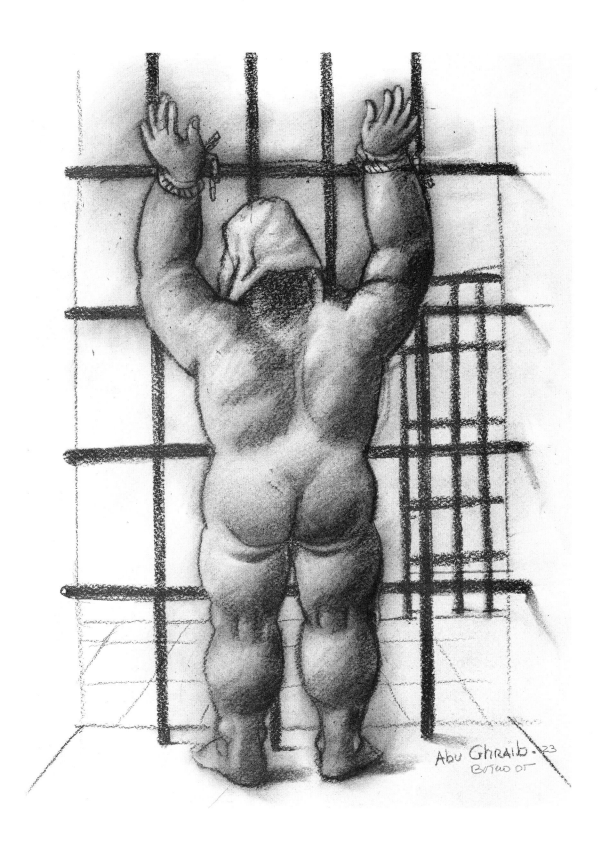

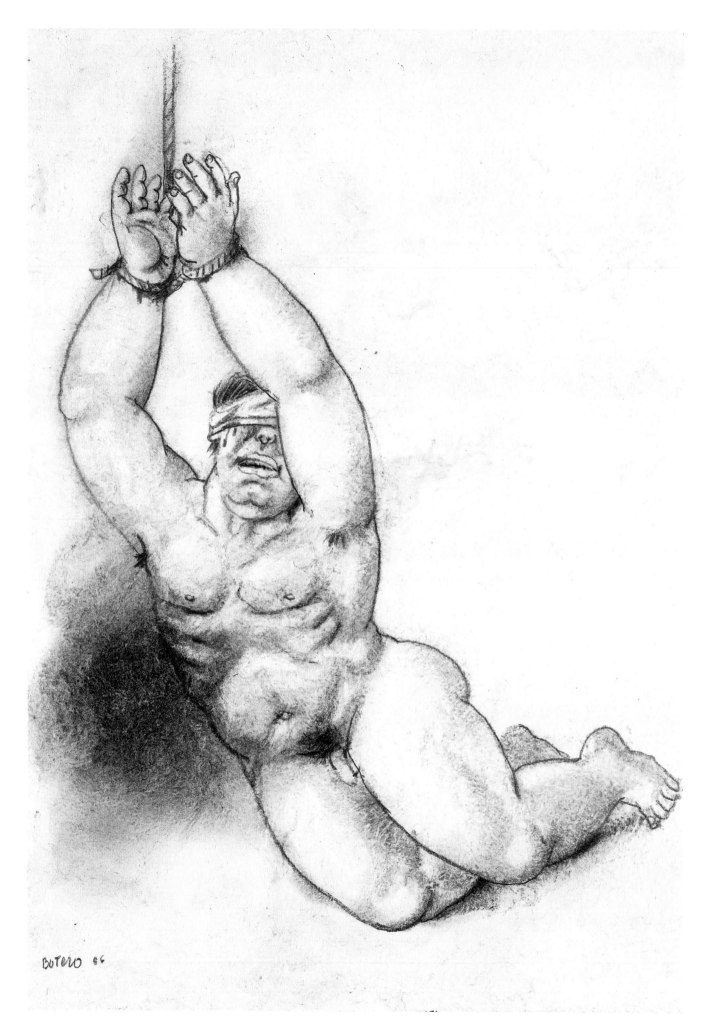

BOTERO 86

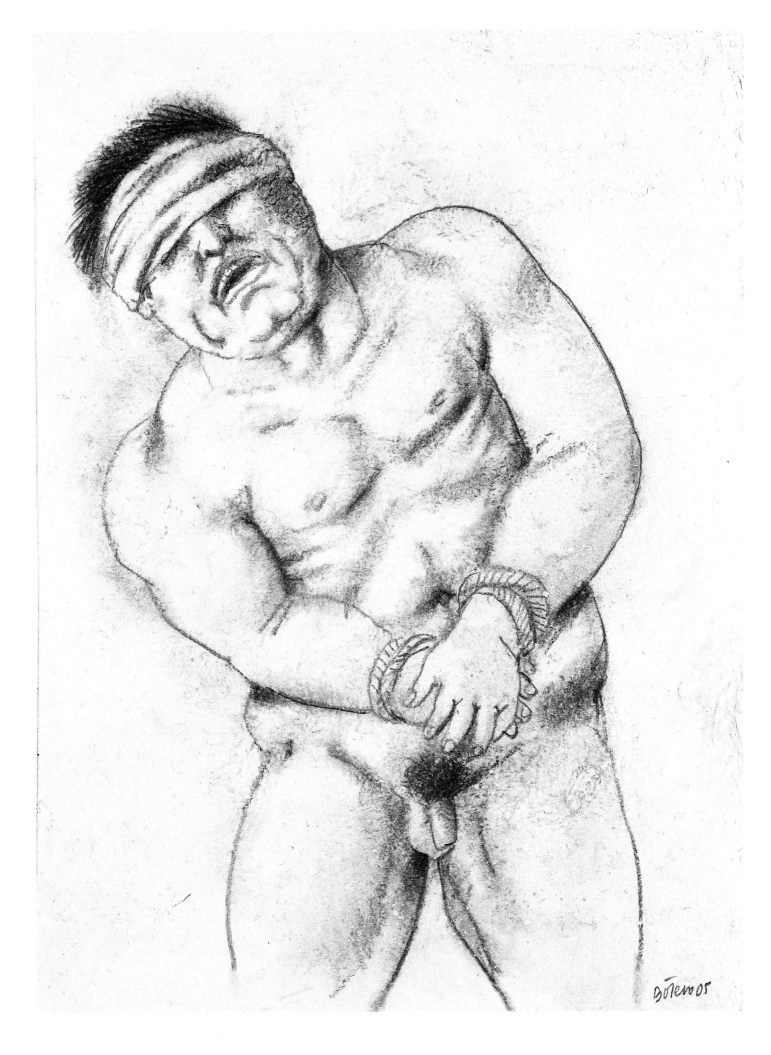

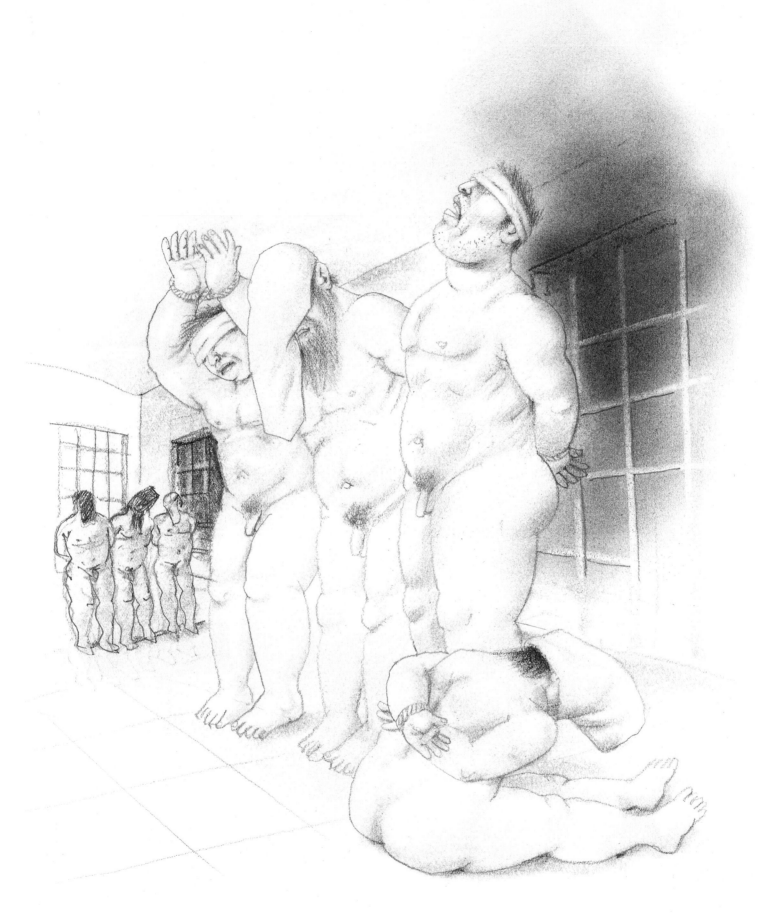

Botero 05

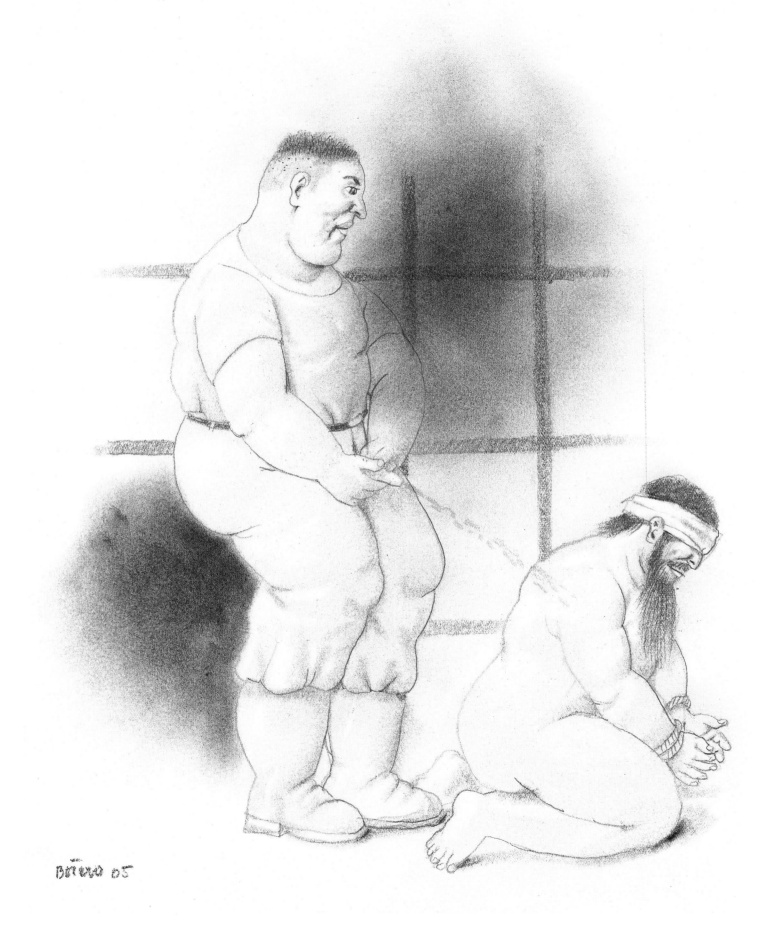

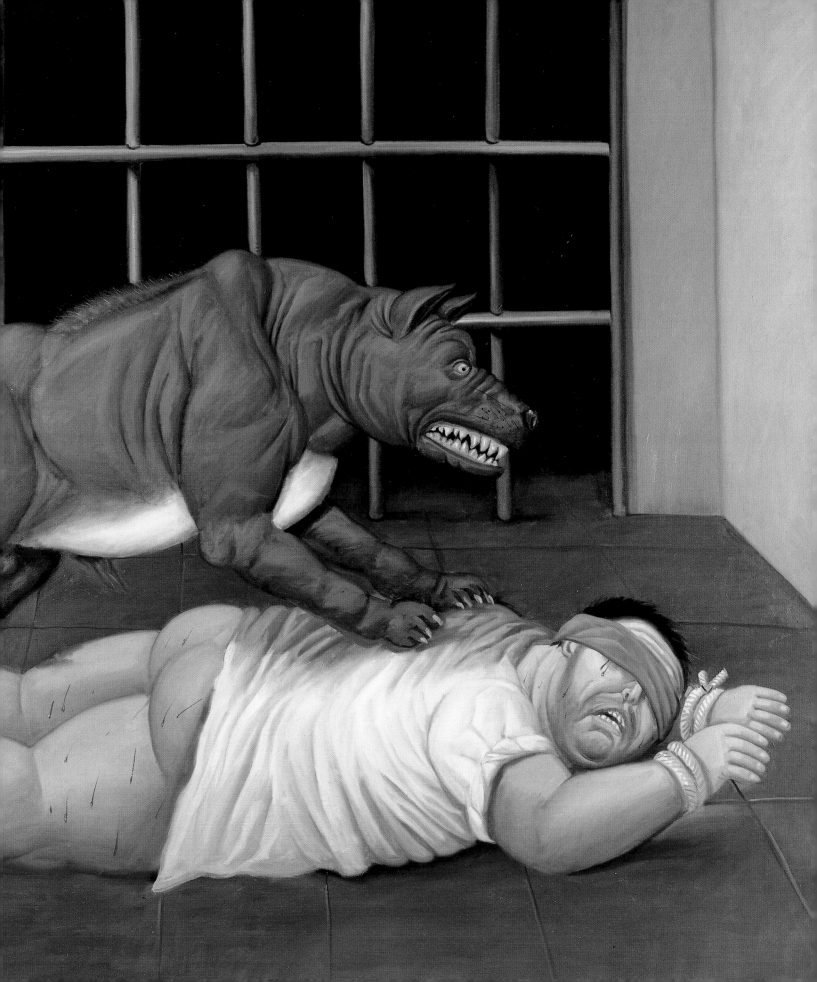

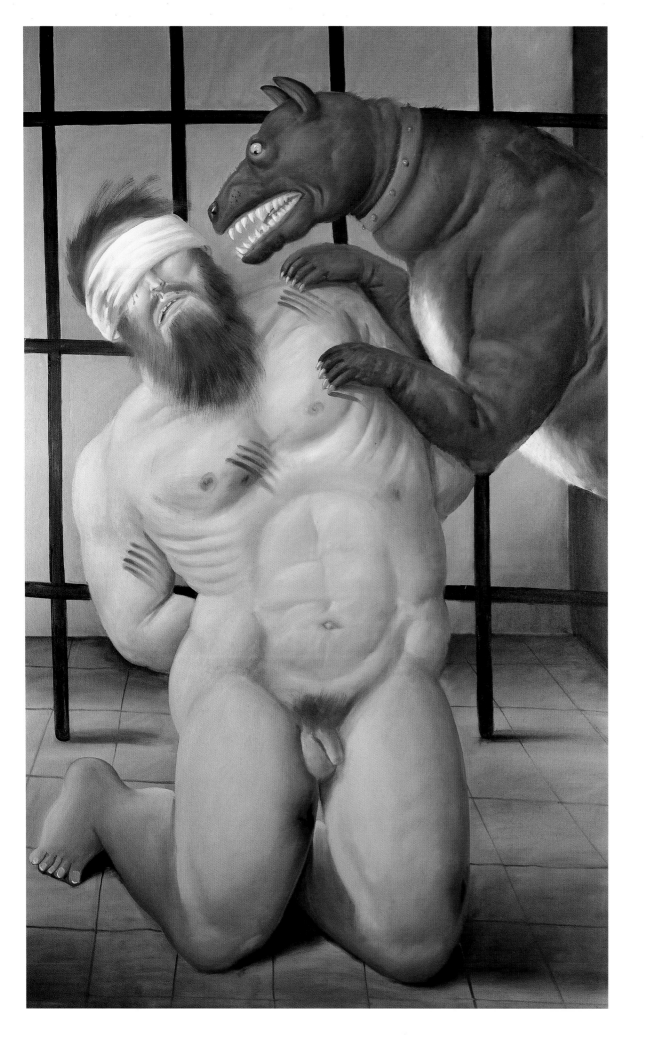

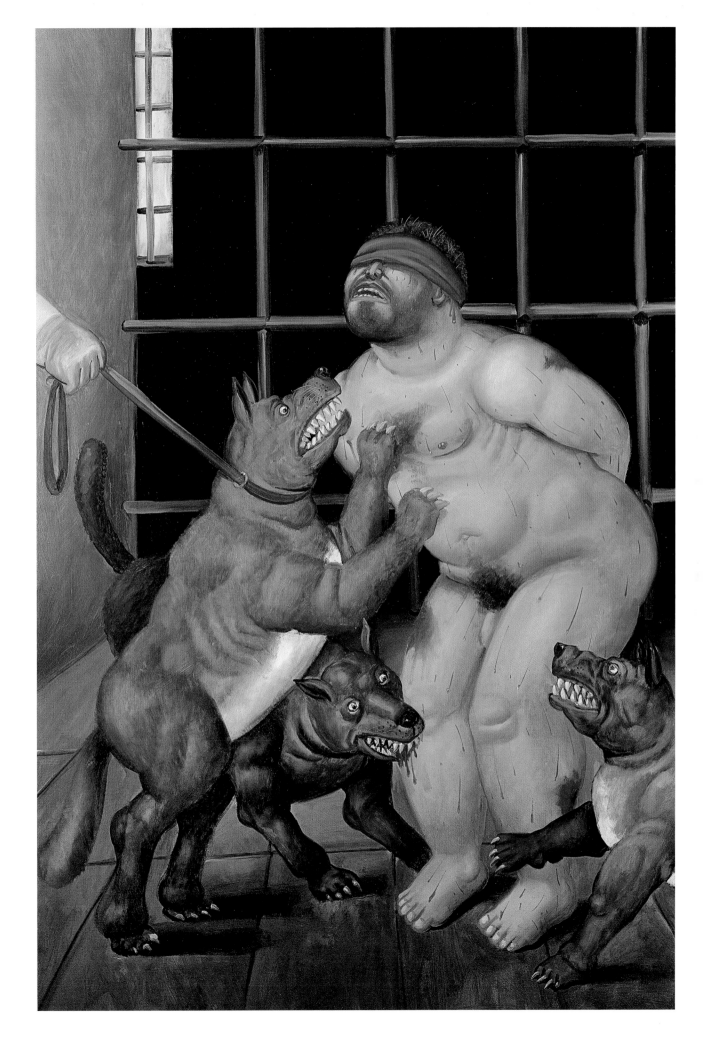

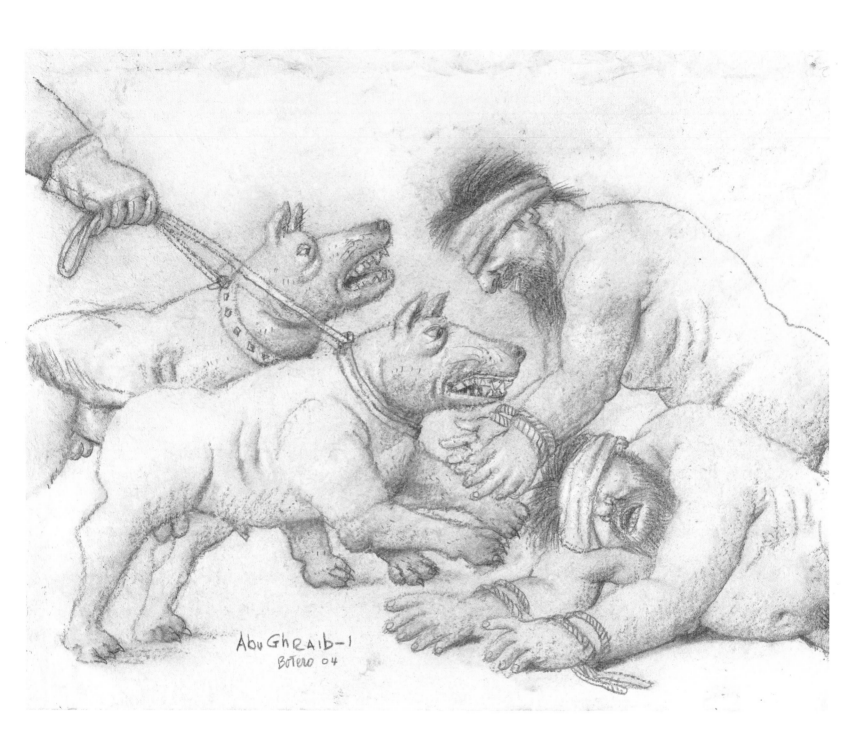

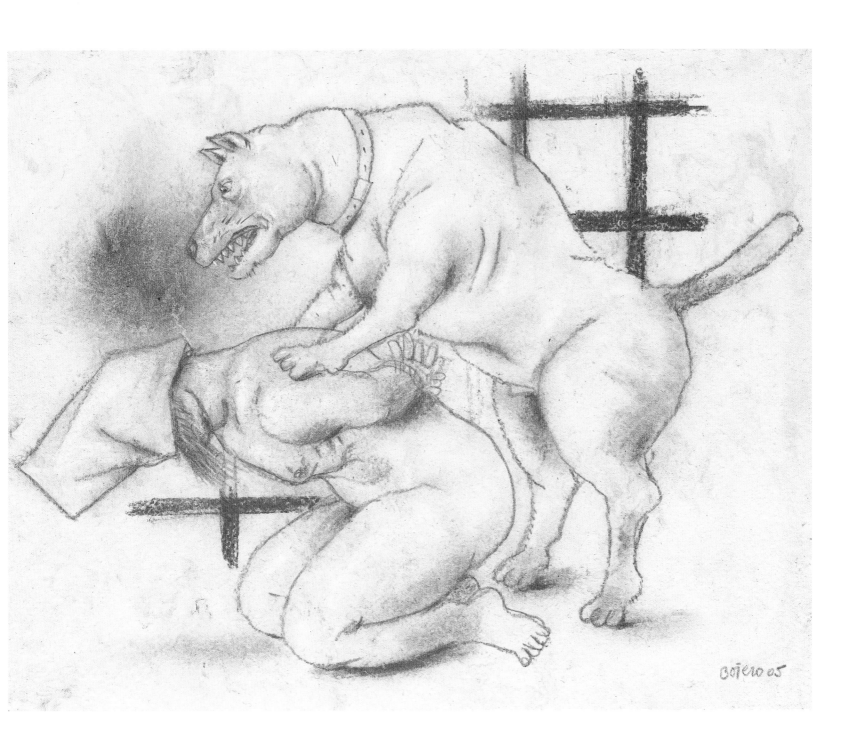

Botero 05

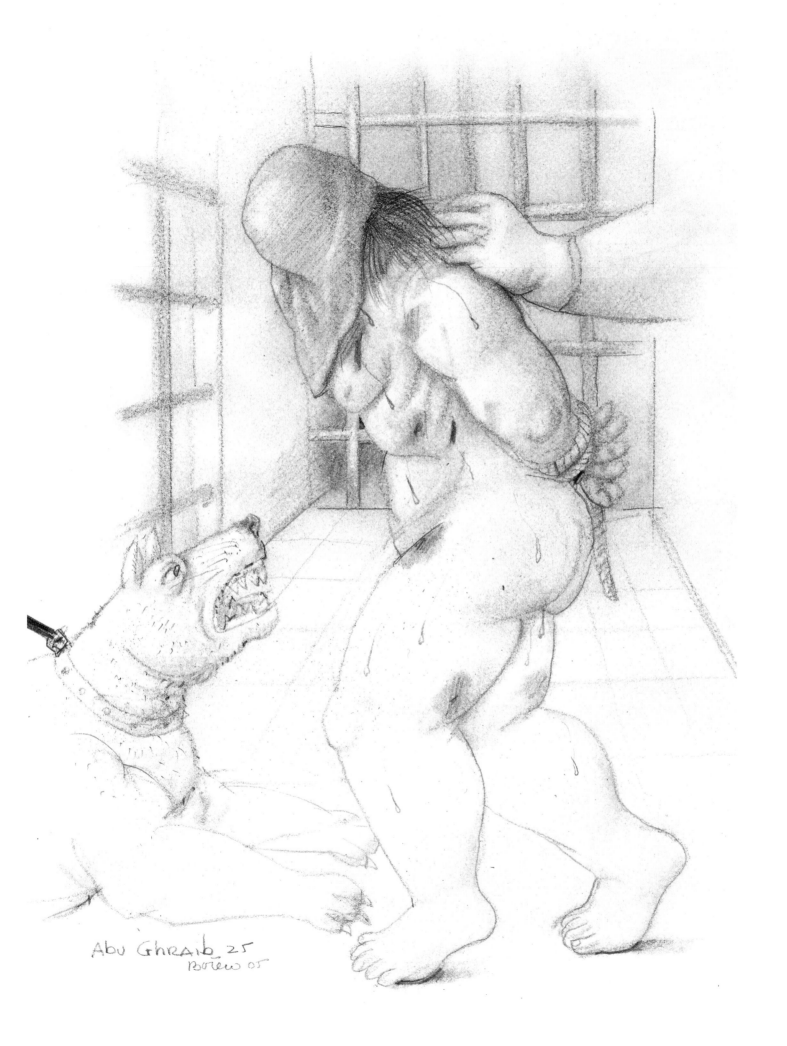

Abu Ghraib 25
Botero 05

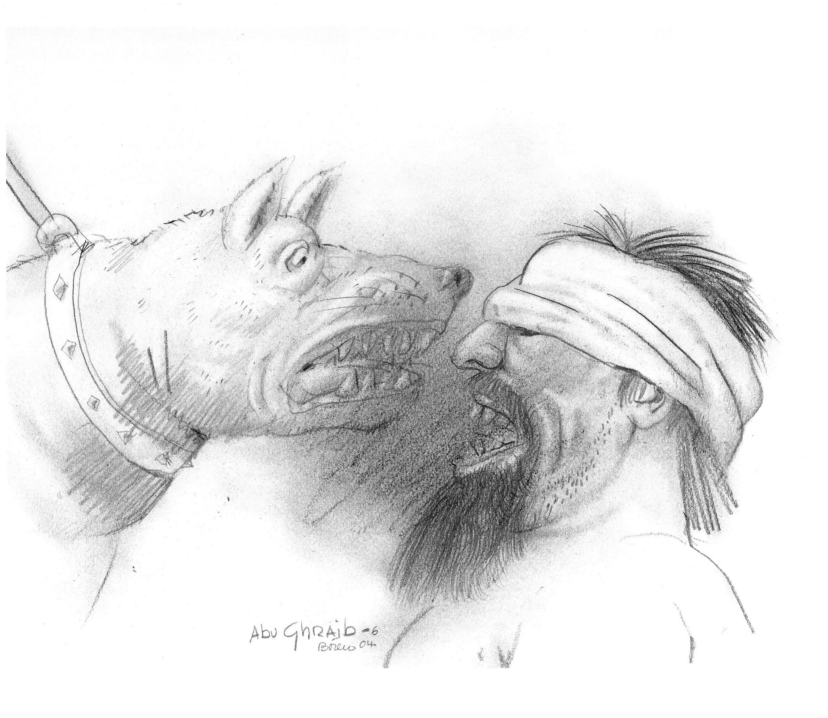

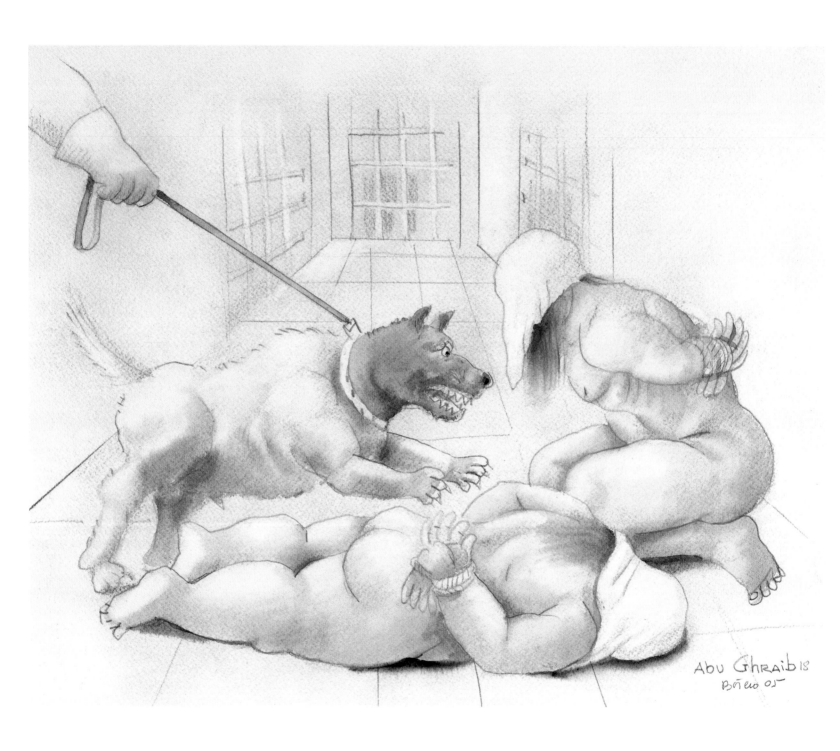

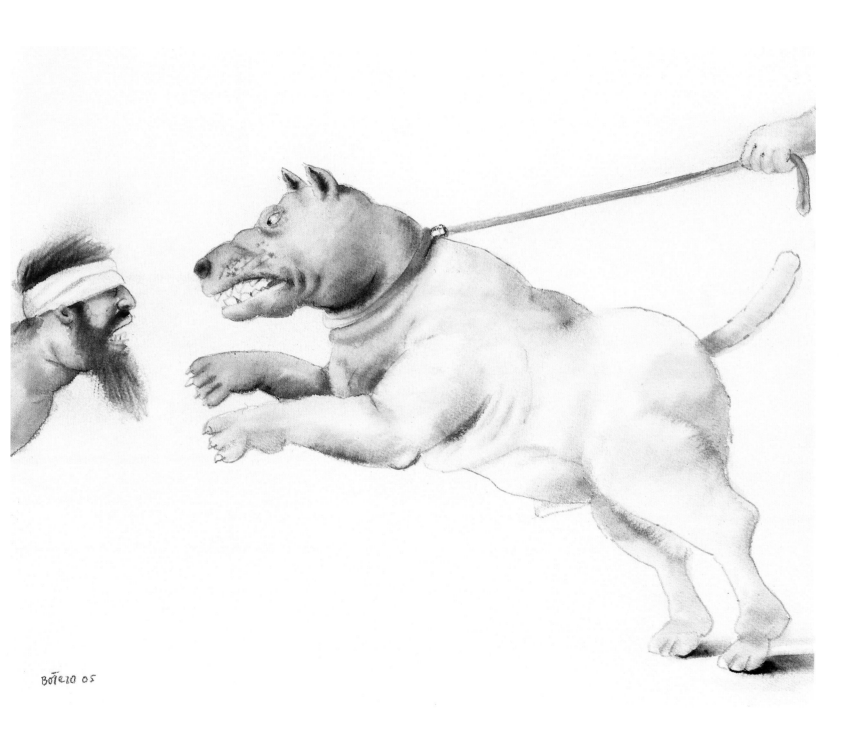

BOTERO 05

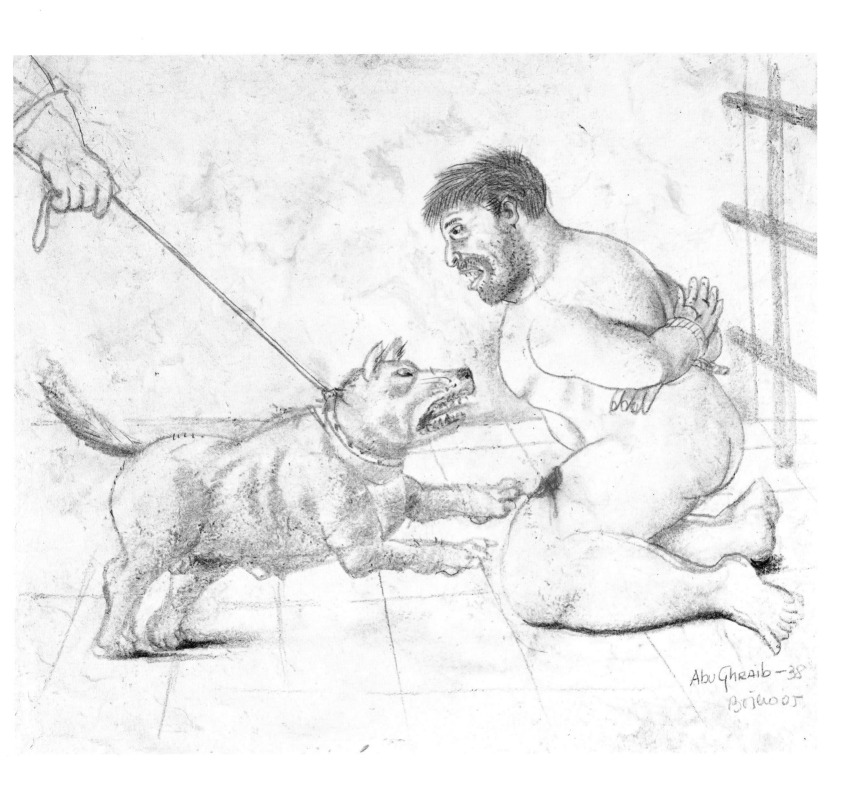

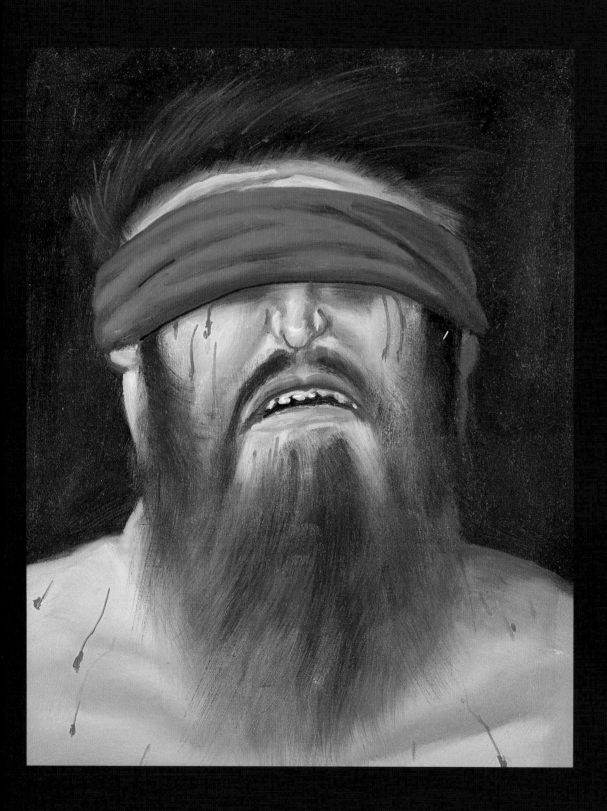

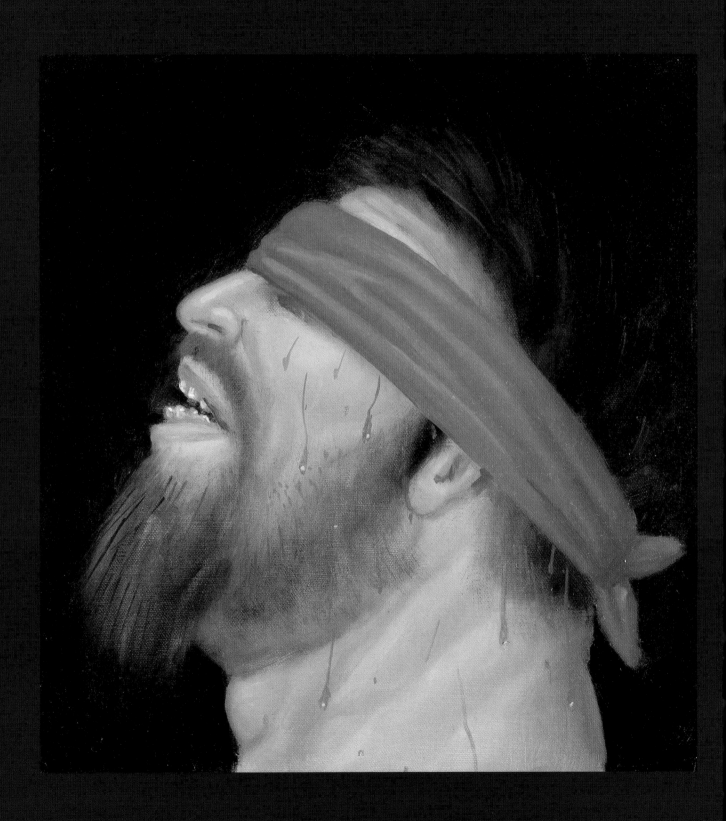

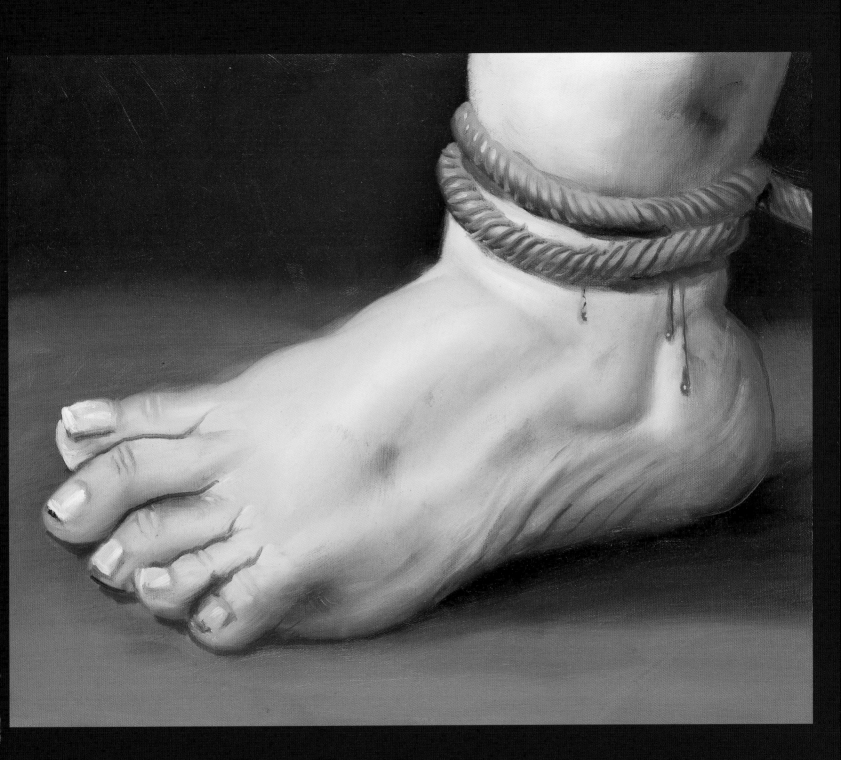

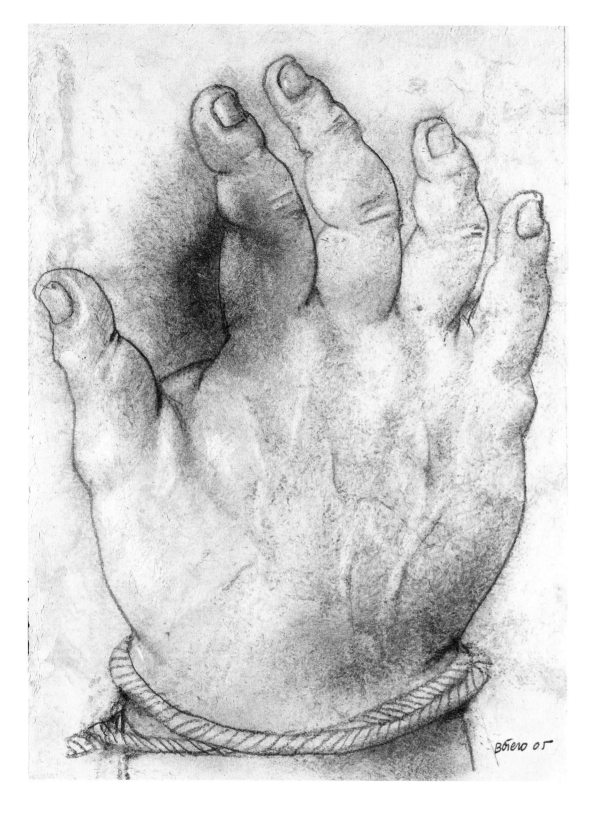

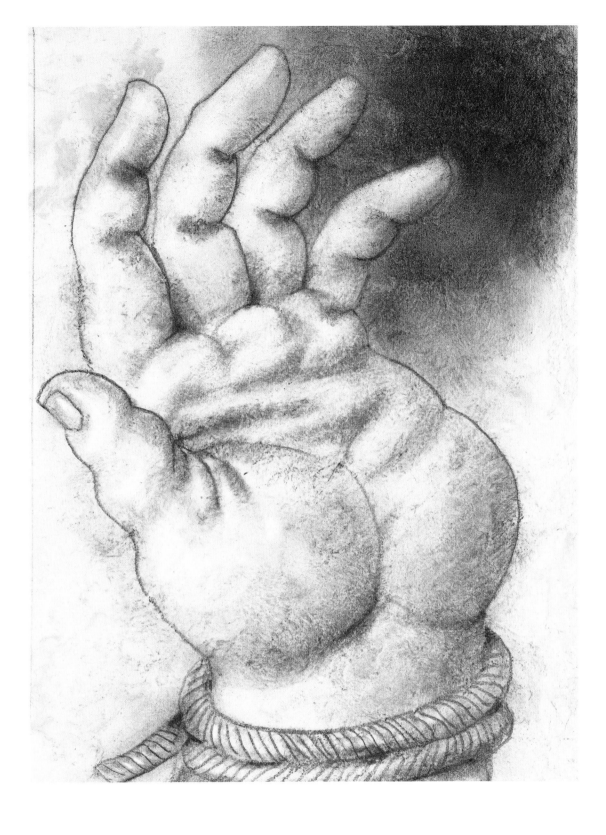

LIST OF WORKS

1932
Fernando Botero is born on April 19 in Medellín (Colombia). His father is a salesman visiting clients in the vicinity on horseback.

1938–49
Botero attends the Jesuit-run grammar school and later a school for matadors in Medellín before attending the Liceo San José in Marinilla. He starts to paint watercolors and earns the school fees by making illustrations for the newspaper El Colombiano.

1950
After graduating from high school, spends two months working as a set designer for a Spanish theater group called "Lope de Vega."

1951
Botero moves to Bogotá, the capital of Colombia. First exhibitions with watercolors, gouaches, drawings, and oil paintings. He sells some of his works and spends the summer on the Caribbean coast.

1952
Wins second prize at the IXth Salon of Colombian artists. He travels to Europe, visits Barcelona, and studies at Academia San Fernando in Madrid. He studies the works of Goya, Rubens, Titian, and Velázquez in the Museo del Prado. Sells copies of their works to tourists.

1953
Visits Paris where he studies the paintings of the Old Masters in the Louvre. Travels to Florence and studies fresco painting at the Accademia San Marco for 18 months.

1955
Returns to Bogotá. His paintings from Florence are exhibited in the National Library, but without success. He marries Gloria Zea.

1956
Botero lives in Mexico City. Becomes impressed by the paintings of the Mexican muralists. First group exhibition in the U.S.A. at the Museum of Fine Arts, Houston.

1957
First one man show in the U.S.A. in Washington, organised by the Pan American Union. He travels to the opening and sells all of his paintings. Back in Bogotá, his son Fernando is born.

1958
Professor of painting at the Academy of Bogotá. His daughter Lina is born. On receiving the Guggenheim International award, he participates in a group exhibition at the Solomon R. Guggenheim Museum in New York.

1959
Works included in the Vth Biennial of São Paulo. He paints paraphrases of the styles of Leonardo and Velázquez.

1960
Fresco for the Banco Central Hipotecario in Medellín. Birth of his second son, Juan Carlos. Guggenheim Award. Separates from Gloria Zea.

1961
Acquisition of *Mona Lisa aged 12* by the Museum of Modern Art, New York.

1962
First exhibition in New York in The Contemporaries Gallery.

1963
Botero works in a studio on New York's Lower East Side.

1964
He marries Cecilia Zambrano.

1965
Travels to Europe for his first important exhibition in Europe in the Kunsthalle Baden-Baden. First solo exhibition in a U.S. museum at the Milwaukee Art Center.

1969
Exhibition of paintings and large charcoal drawings in the Center for Inter-American Relations. First solo exhibition in France.

1970
Birth of his son Pedro.

1971
Rents an apartment in Paris. Botero lives in Paris, Bogotá, and New York, where he maintains a studio on Fifth Avenue.

1972
First exhibition at Marlborough Gallery, New York.

1973
Botero moves to Paris. First sculptures.

1974
First retrospective exhibition in Bogotá. His four-year-old son Pedro dies in a car accident.

1975
Botero separates from Cecilia Zambrano. In memory of his son he donates 16 works to the Museo de Zea, Medellín.

1979
First retrospective exhibition in the U.S. at the Hirshhorn Museum, Washington, D.C.

1981
Retrospective exhibitions in Tokyo and Osaka.

1983
Studio in Pietrasanta, Tuscany, where he works on sculptures. He donates sculptures to the Museum Antioquía in Medellín and 18 paintings to the National Library in Bogotá in 1984.

1987
Exhibition of Bullfight series of paintings, watercolors, and drawings in Milan, Naples, and Knokke (Belgium).

1991
Exhibition of Botero's monumental sculptures in the Forte Belvedere in Florence, and on the Champs-Elysées in Paris (1992).

1993
Exhibition of 18 monumental bronzes on Park Avenue in New York.

1994
Exhibition of his sculptures in Madrid. Botero escapes being kidnapped in Bogotá.

1995
A bomb explodes close to Botero's large sculpture *Bird* in Medellín. 27 people die.

1998
A major retrospective tours Latin America.

1999
Exhibition of 30 monumental sculptures on Piazza della Signoria in Florence.

2000
Donation of 100 masterpieces of Beckmann, Chagall, Corot, Dalí, Degas, Picasso, and other painters from his private collection to two museums in Medellín and Bogotá.

2001–3
Major retrospectives in Mexico City and Scandinavia, and in the Gemeentemuseum, The Hague.

2004
Begins Abu Ghraib series in response to news reports of the scandal.

2005–6
First exhibition of Abu Ghraib paintings in the Palazzo Venezia, Rome, and Kunsthalle Würth in Schwäbisch Hall (Germany).

Front cover: Fernando Botero, *Abu Ghraib 67*, 2005, 35 x 43 cm

Cover design: Mark Grünberger, Dada Weiss

The Library of Congress Cataloguing-in-Publication data is available; British Library Cataloguing-in-Publication Data: a catalogue record for this book is available from the British Library; Deutsche Bibliothek holds a record of this publication in the Deutsche Nationalbibliografie; detailed bibliographical data can be found under: http://dnb.ddb.de

© Prestel Verlag, Munich · Berlin · London · New York, 2006

© of the works illustrated by Fernando Botero by the artist; Paul Cadmus by DC Moore Gallery, New York; Leon Golub, Richard Serra, and David Alfaro Siqueiros by VG Bild-Kunst, Bonn 2006; Gerald Laing by the artist; Andy Warhol by Andy Warhol Foundation for the Visual Arts/ARS, New York 2006

Photograph of painting by Paul Cadmus courtesy DC Moore Gallery, New York

Photograph of painting by Leon Golub courtesy Ronald Feldman Fine Arts, New York

Photograph of Richard Serra work courtesy Whitney Museum of American Art, New York

Prestel Verlag, Königinstrasse 9, 80539 Munich
Tel. +49 (89) 38 17 09-0; fax +49 (89) 38 17 09-35
www.prestel.de

Prestel Publishing Ltd., 4 Bloomsbury Place, London WC1A 2QA
Tel. +44 (020) 7323-5004; fax +44 (020) 7636-8004

Prestel Publishing, 900 Broadway, Suite 603, New York, NY 10003
Tel. +1 (212) 995-2720; fax +1 (212) 995-2733
www.prestel.com

Design and layout: Mark Grünberger, Dada Weiss

Origination: Repro Ludwig, Zell am See, Austria

Printing: Aumüller Druck, Regensburg

Binding: Conzella, Pfarrkirchen

Printed in Germany on acid-free paper

ISBN 3-7913-3741-6
978-3-7913-3741-8